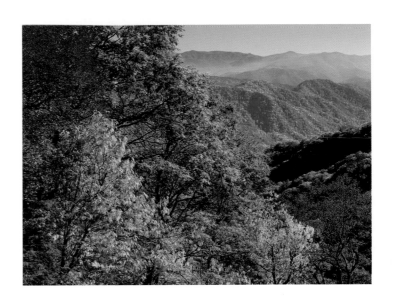

NORTH CAROLINA

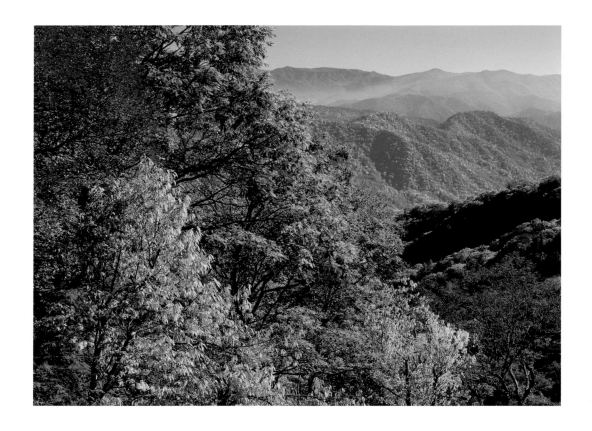

AMERICA SERIES

Text by Tanya Lloyd Kyi
Edited by Elaine Jones
Photo editing by Tanya Lloyd Kyi
Cover and Interior design by Robert Batchelor; updated by Neuwirth & Associates
Proofread by Elizabeth McLean
Desktop publishing by Susan Greenshields
Front Cover by Dave Allen Photography

Printed and bound in China.

Library of Congress Control Number: 2013951401
ISBN: 978-1-94041-620-5

For more information on the America Series titles, please visit Midpoint Trade Books at
www.midpointtrade.com.

The historic Appalachian Trail follows the western border of North Carolina between peaks towering over 6,000 feet. Hikers are awestruck by the stunning Great Smoky Mountains National Park, truly one of the nation's most important natural treasures. The park and its surroundings boast an astonishing diversity of plants and animals and more species of trees than are found in all of Europe. Here, too, are the Pisgah and Nantahala National Forests, the Blue Ridge Mountains, the Linville and Whitewater rivers, and scenic by ways of national importance.

East of the mighty Appalachian Range are the rolling foothills or Piedmont region of the state—home to North Carolina's largest cities and financial centers. The city of Charlotte is a cosmopolitan center of arts, professional sports, history, and commerce. Further east, the state capital of Raleigh buzzes with industry, its modern skyscrapers rising between historic buildings dating from the 18th century.

South of Raleigh is the Cape Fear River, with its treacherous delta that forms the southernmost tip of the state's Atlantic shoreline. Like the rest of North Carolina, the coastal area is steeped in history. The pirate Edward Teach, known to mariners as Blackbeard, settled in the town of Bath in 1718. In 1903, brothers Orville and Wilbur Wright achieved sustained flight at the coastal town of Kitty Hawk, launching aeronautics and international air travel.

Across North Carolina, from Wilmington to Winston-Salem, visitors can take in sights of great historic interest and natural splendor. Many turning points in America's early days unfolded in this great state, from the battle for independence to the birth of powered flight. Here, the past is preserved and honored—a treasure for generations to come.

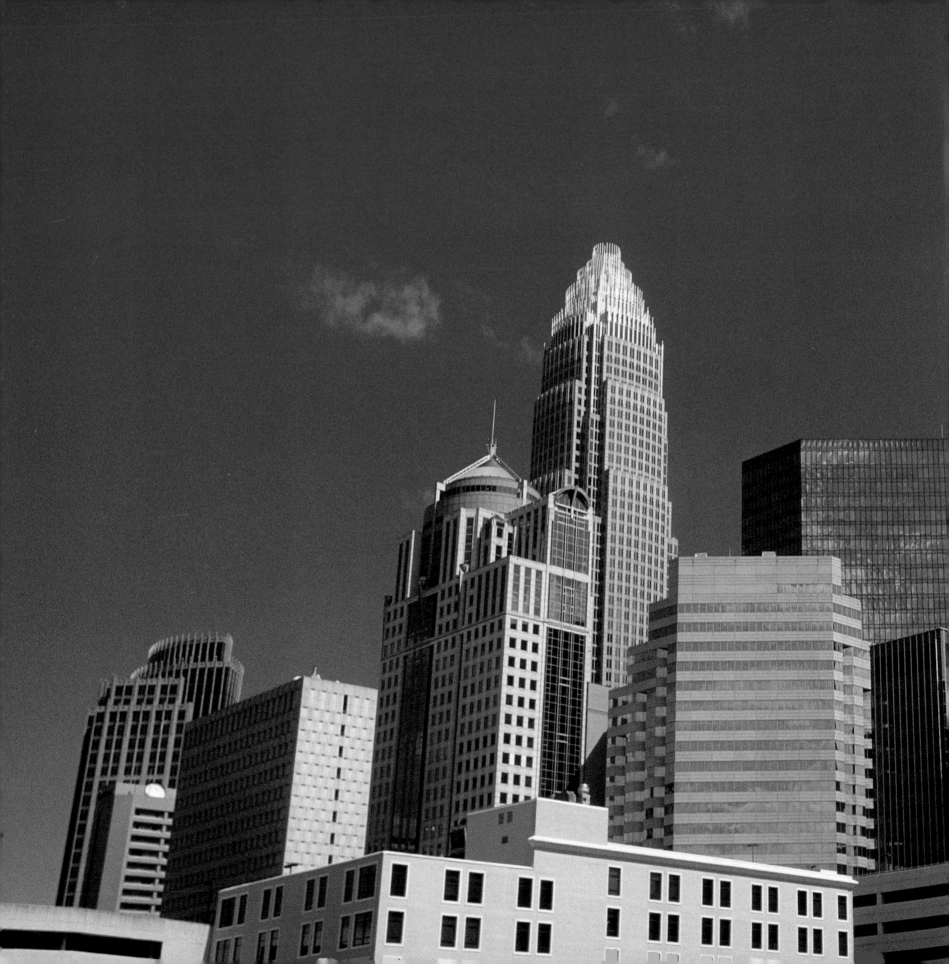

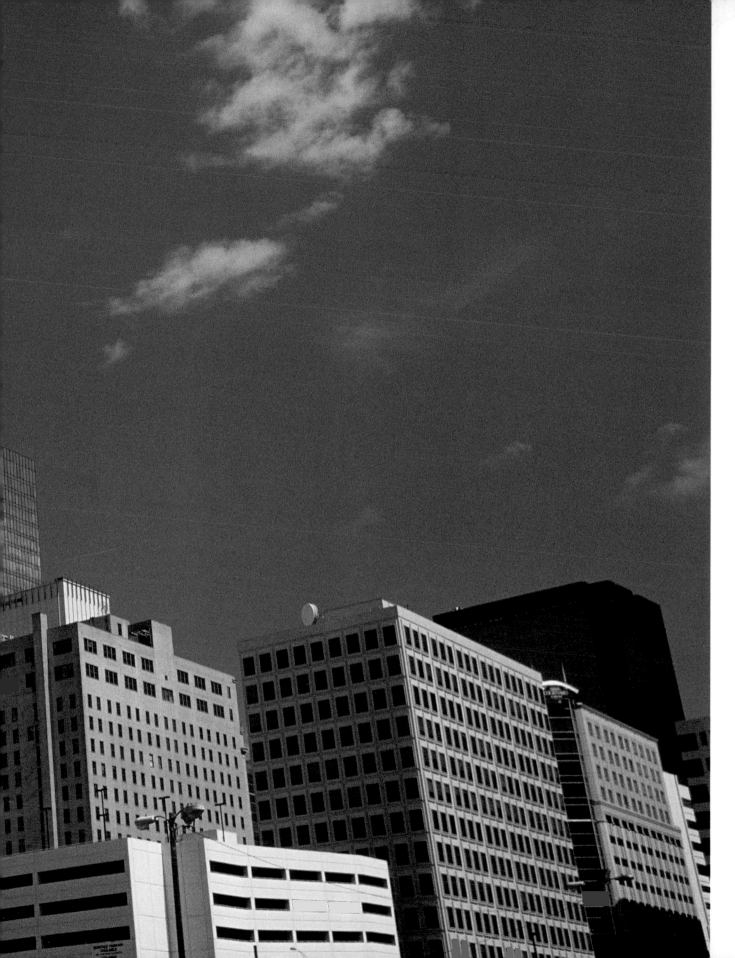

More than two centuries ago, George Washington passed through Charlotte and called the young city "a trifling place." Since then, this cosmopolitan center has become one of the country's 25 largest cities, offering unmatched business opportunities as well as an array of sports and cultural events.

7

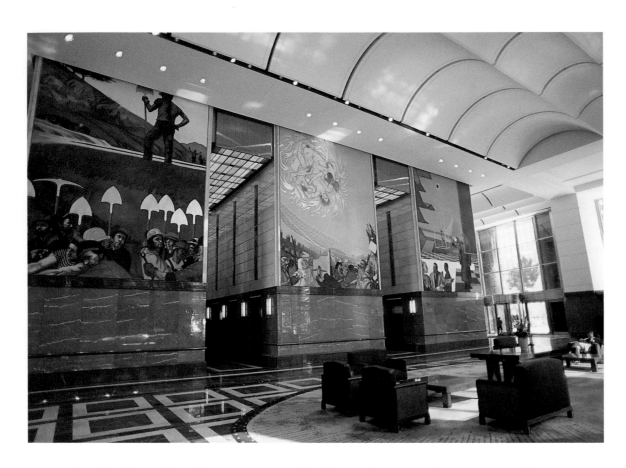

More banks have headquarters in Charlotte than in almost any other American city. This ornate lobby welcomes clients to the Bank of America, one of the country's largest financial institutions.

Crowds of over 73,000 fans swamp the Bank of America Stadium when the NFL's Carolina Panthers are in town. The city is also home to the NBA's Charlotte Bobcats and to NASCAR events at Lowe's Motor Speedway.

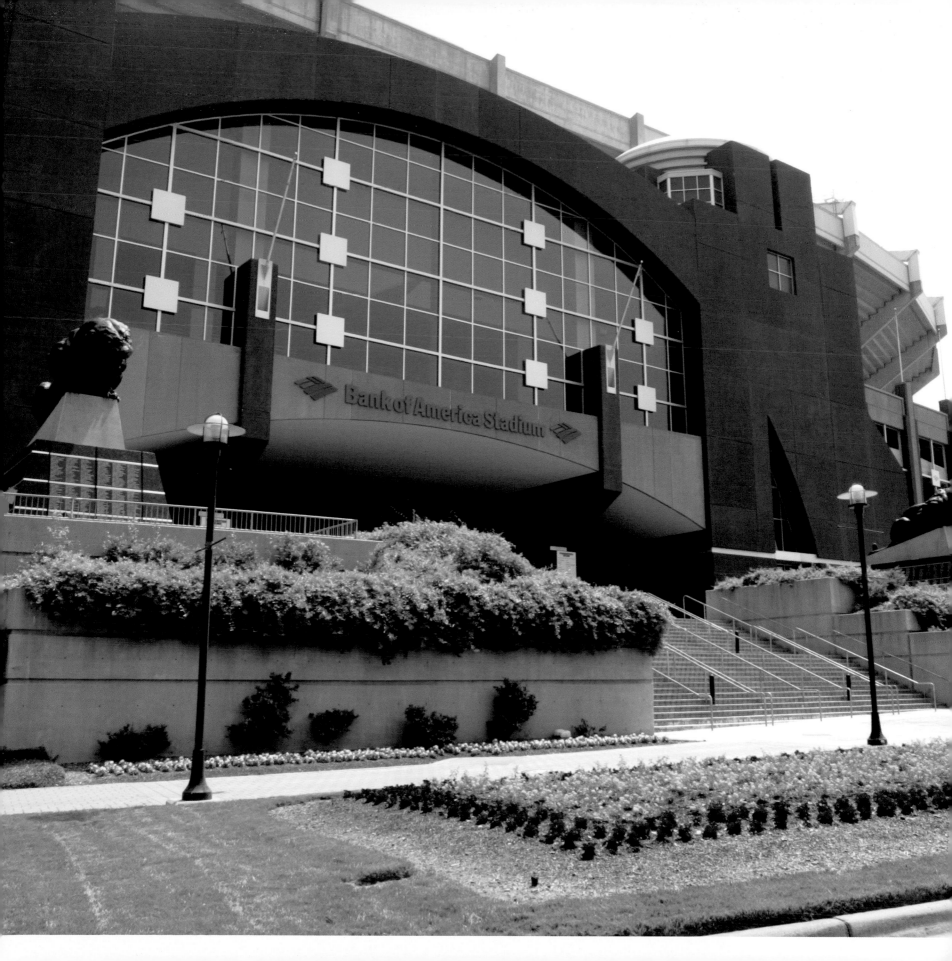

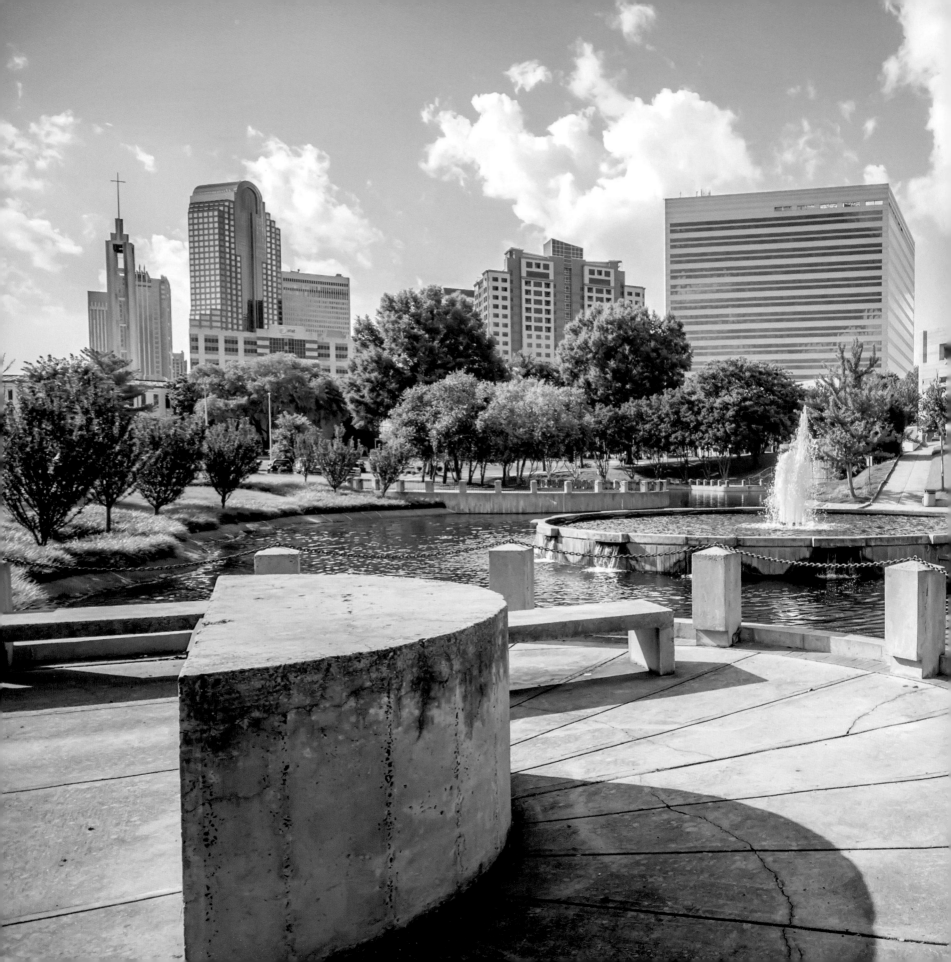

Featuring a large, open grassy area, amphitheater, a fountain, and a lake, the six and a half acre Marshall Park in the Second Ward in known for its unobstructed view of the Charlotte skyline. Its proximity to center city occasionally makes it the site of protester camps and demonstrations.

In the early 1900s, trolleys were a common sight, whisking businesspeople around the city. Today, the restored No. 85 is back in service, offering sightseers an exciting tour through the downtown district.

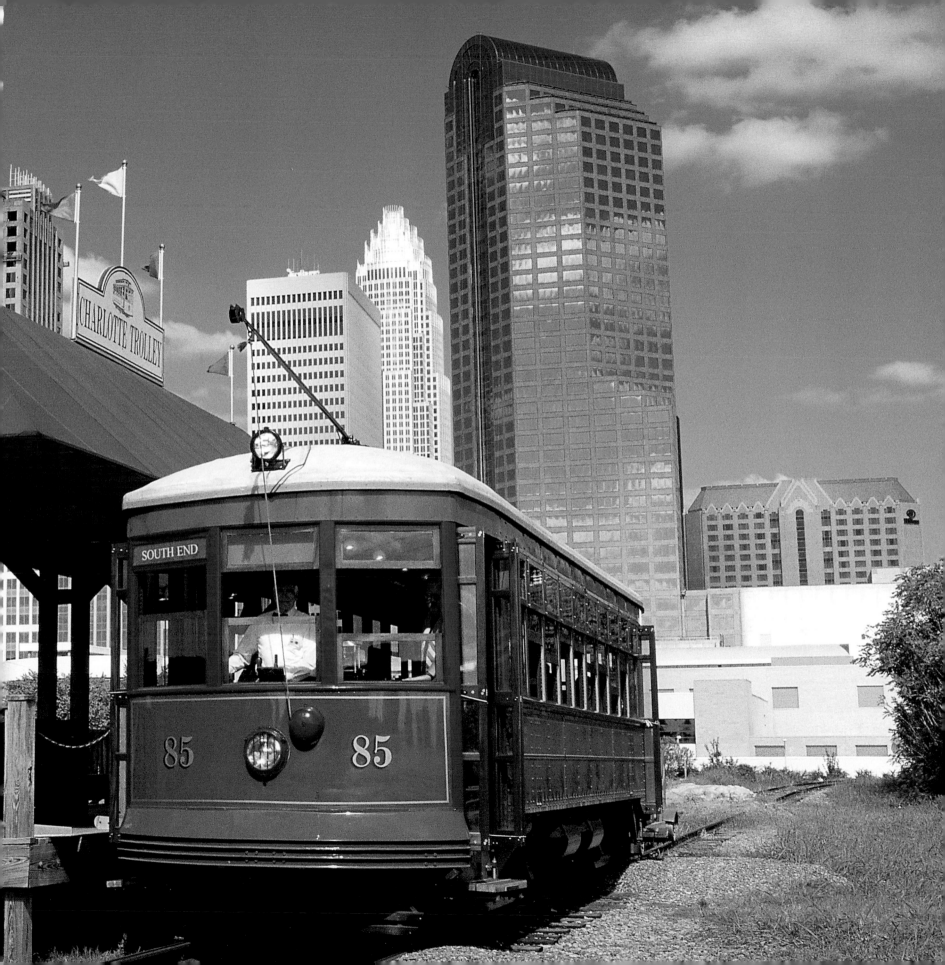

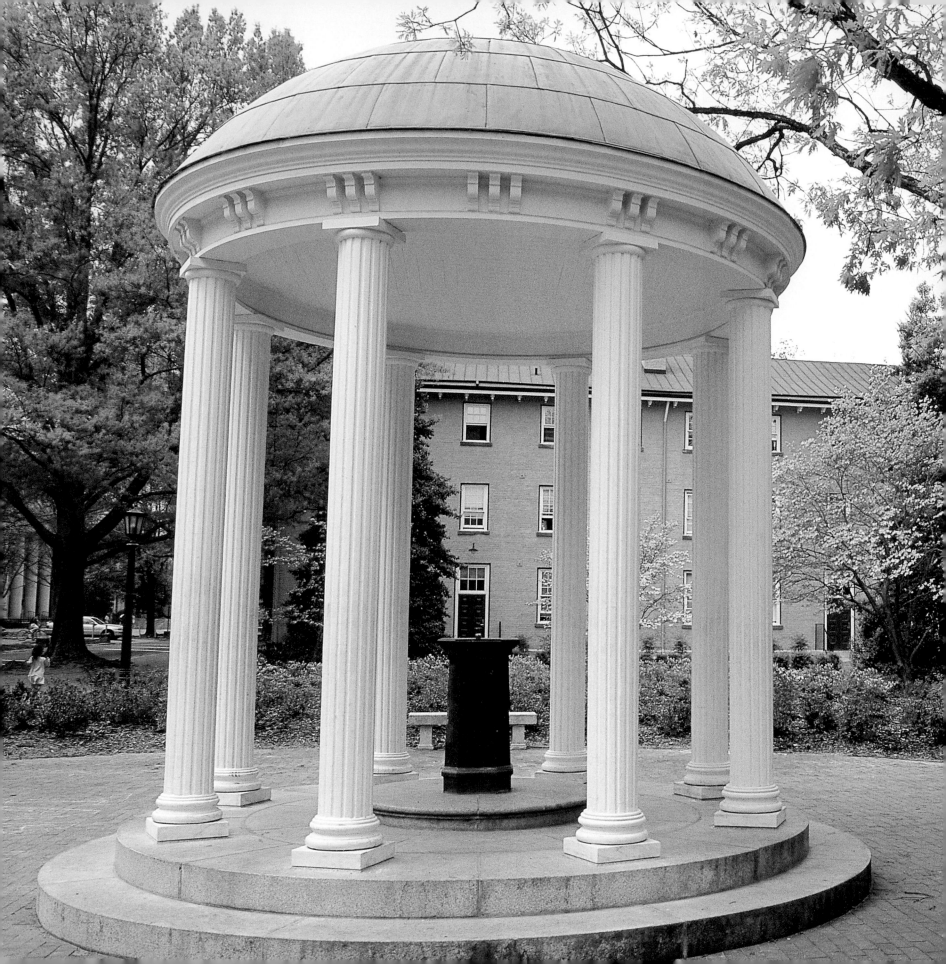

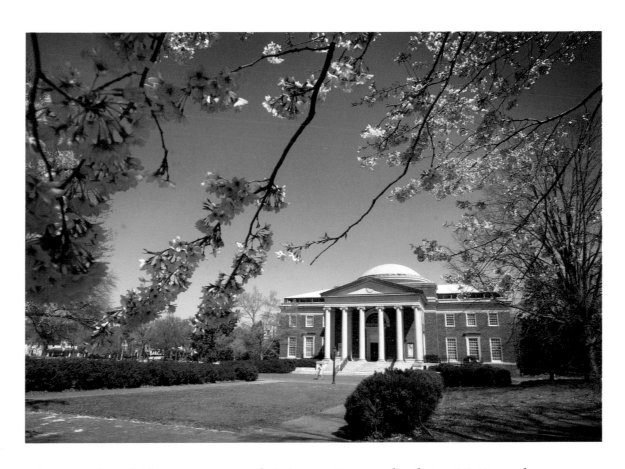

The Morehead Planetarium and Science Center, built in 1949 at the University of North Carolina, was used to train astronauts for the early Mercury and Apollo-Soyuz space programs.

The University of North Carolina was America's first public university. Students attended classes at Chapel Hill, the institution's oldest campus, as early as 1795. This is now one of 16 university campuses across the state.

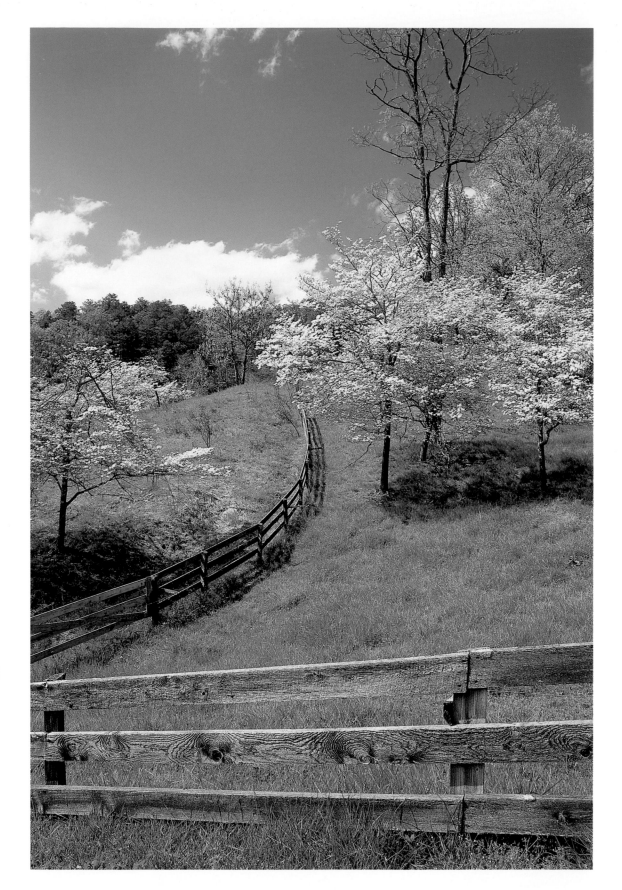

Swain County, a region of agricultural valleys and forested slopes, is bordered by the state of Tennessee to the northwest. The region was named for David L. Swain, a former state governor and past president of the University of North Carolina.

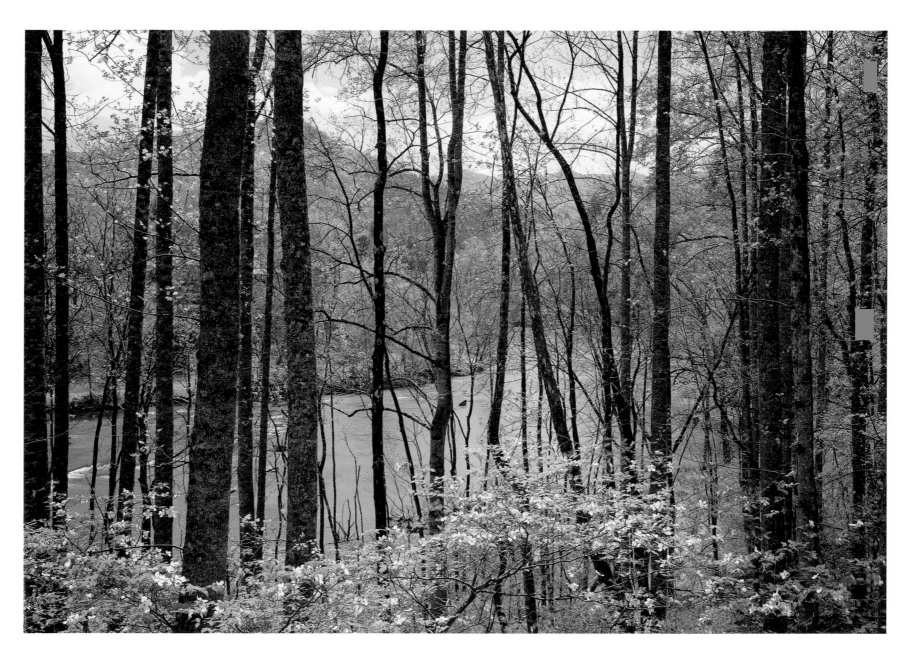

Spring brings new growth to trees above the Little Tennessee River, a place that looks much as it did more than two centuries ago. On April 12, 1776, North Carolina adopted the Halifax Resolves and became the first colony in America to call for independence from Britain.

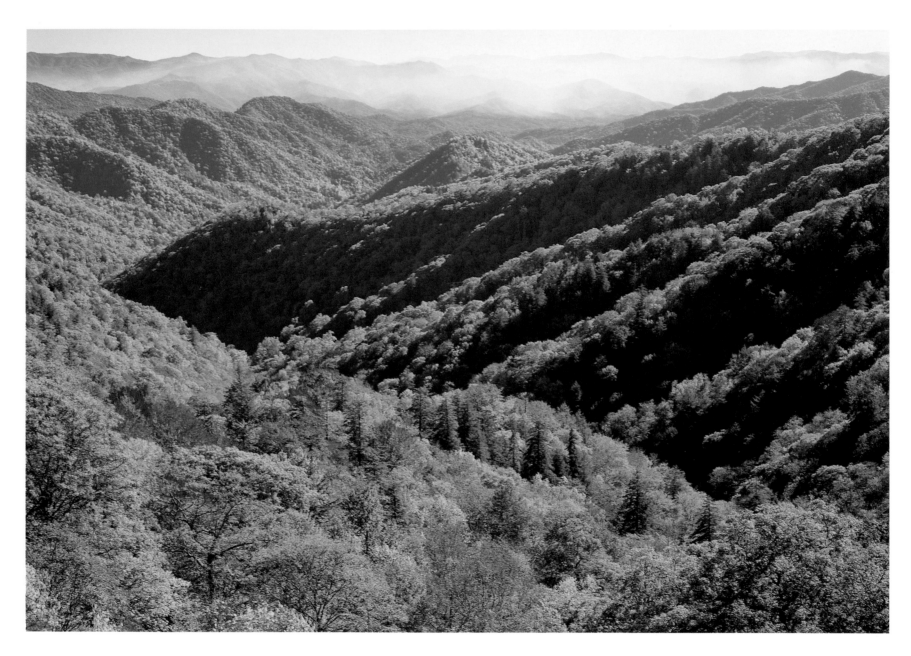

The Great Smoky Mountains are named for the low clouds that hang
like smoke over the peaks. In recognition of the region's cultural and
biological importance, the United Nations has named the national
park an International Biosphere Reserve and a World Heritage Site.

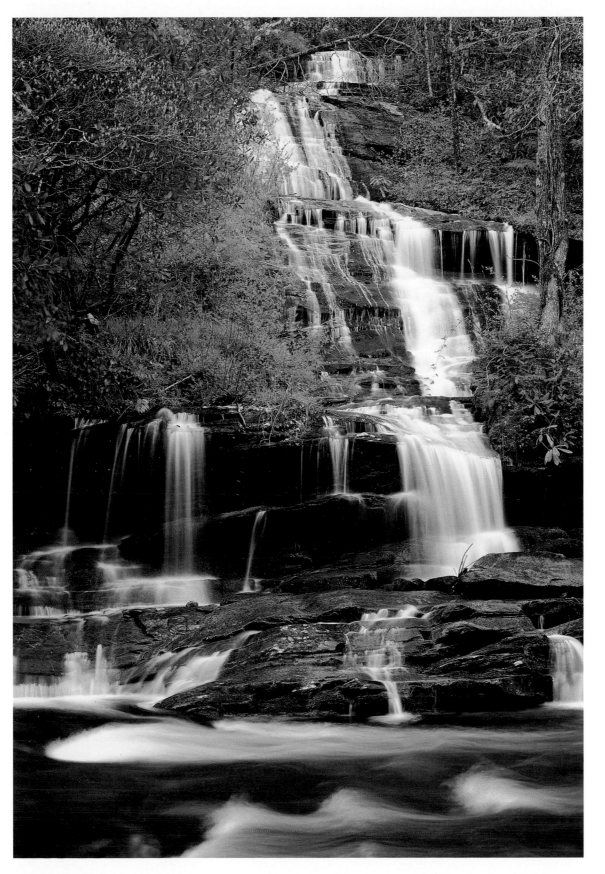

Toms Branch Falls on Deep Creek in Great Smoky Mountains National Park is one of about 250 falls created by the streams and rivers of Transylvania County. Together, these waterways course over 200 miles in this county alone.

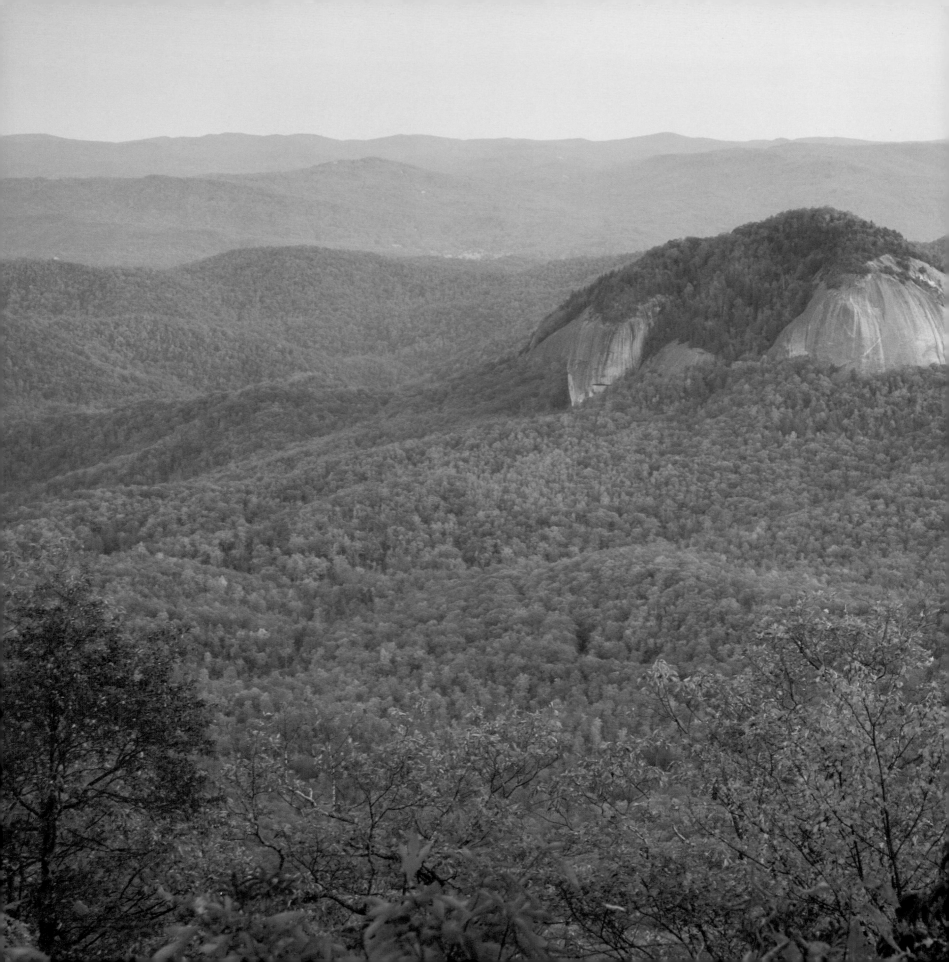

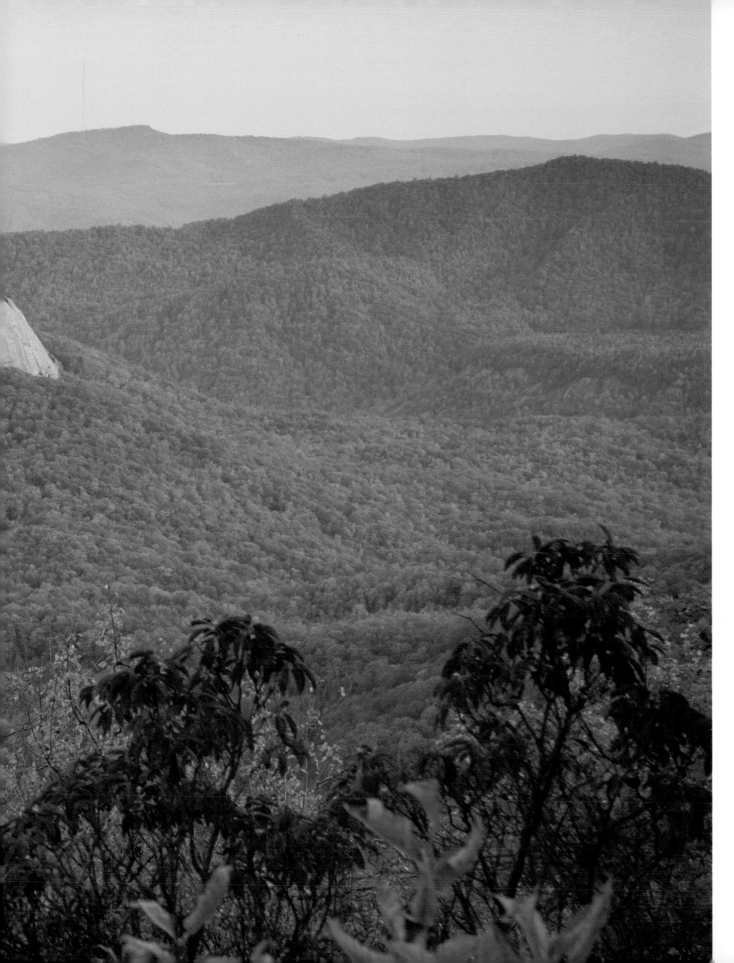

Named for the
way its granite face
reflects the sunshine,
Looking Glass Rock
rises above the
treeline in Pisgah
National Forest

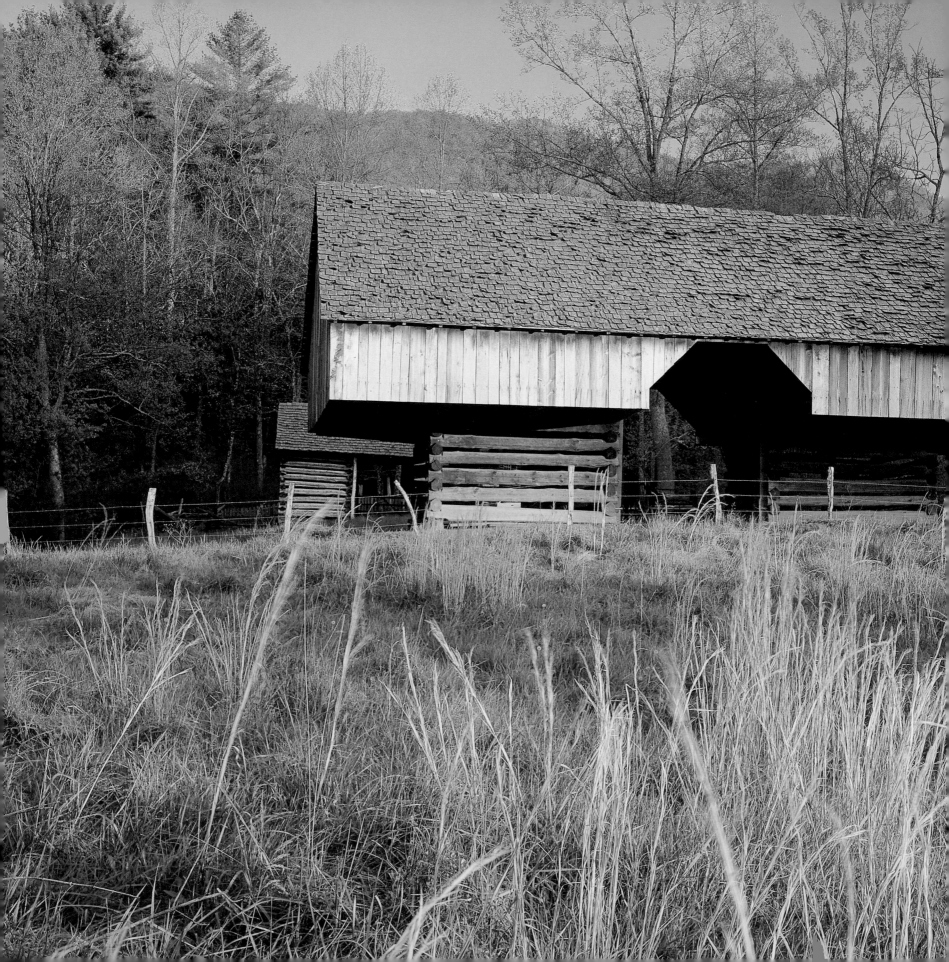

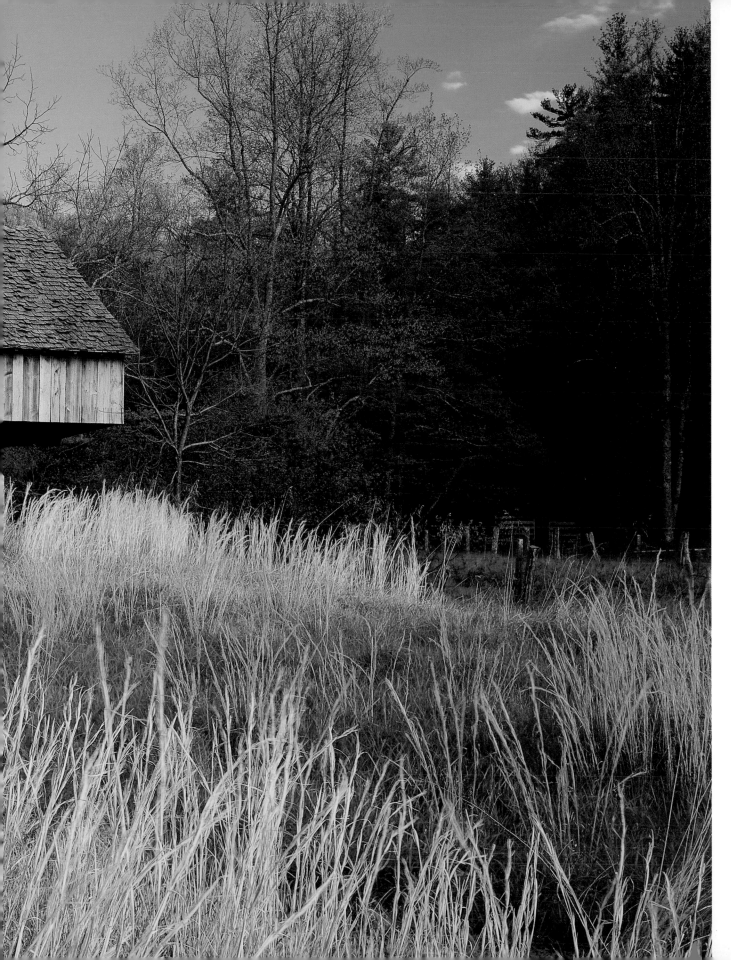

The Great Smoky Mountains span the border between North Carolina and Tennessee. When the national government began to purchase the more than 6,000 plots of private land within the park's boundaries, it received $2.5 million in funding from the state governments and an additional $2.5 million in private donations.

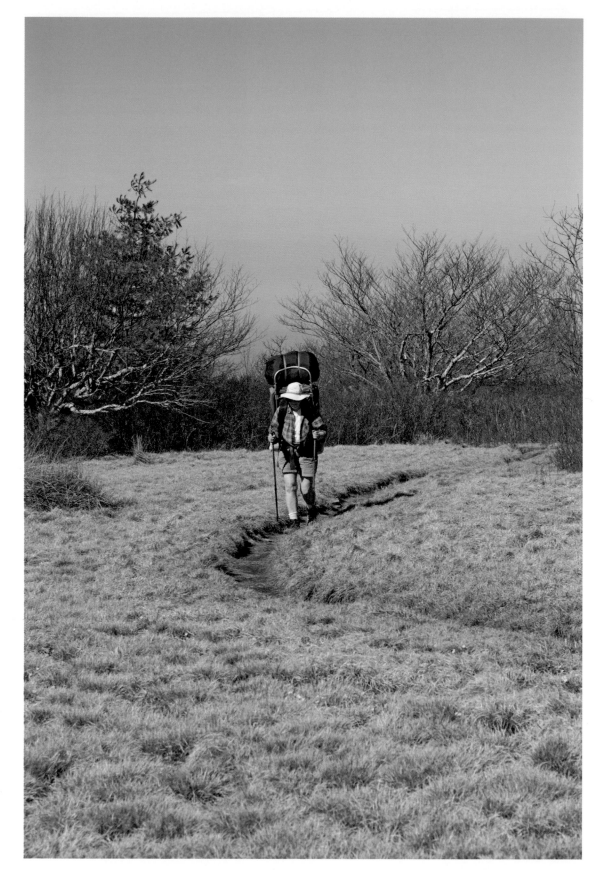

North Carolina is a back-packer's paradise, providing a diverse series of hikes and summits for all levels of experience. Unlike most heavily-forested summits or jagged peaks in the Appalachians, Gregory Bald in the Smoky Mountains is covered by a thick layer of wild grass

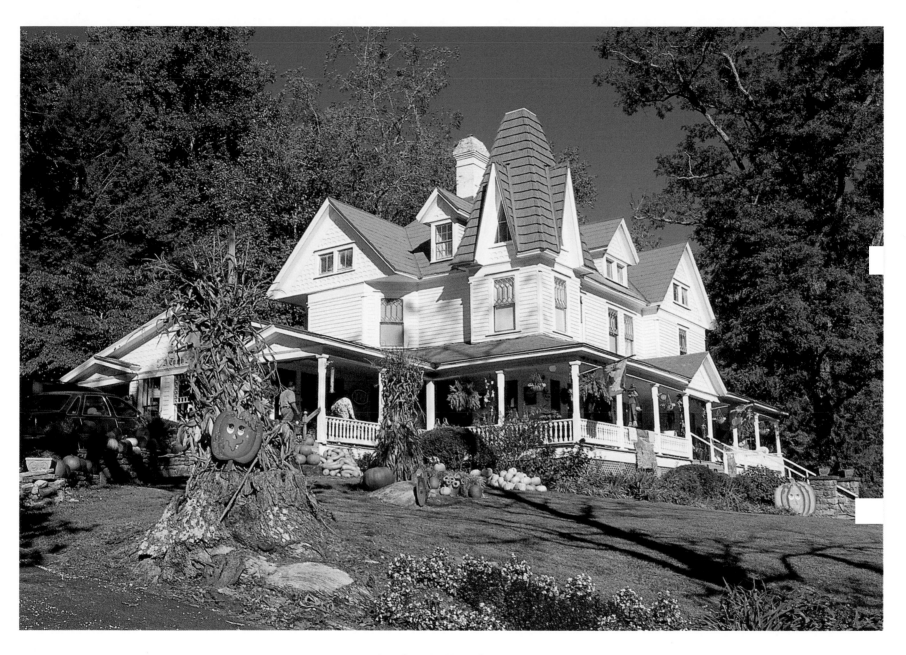

In the foothills of the Blue Ridge Mountains, the community of Bat Cave is a gateway to an outdoor enthusiast's paradise. Hiking at Chimney Rock Park, boat tours on Lake Lure, or canoeing on the Broad River—there are activities to appeal to every visitor.

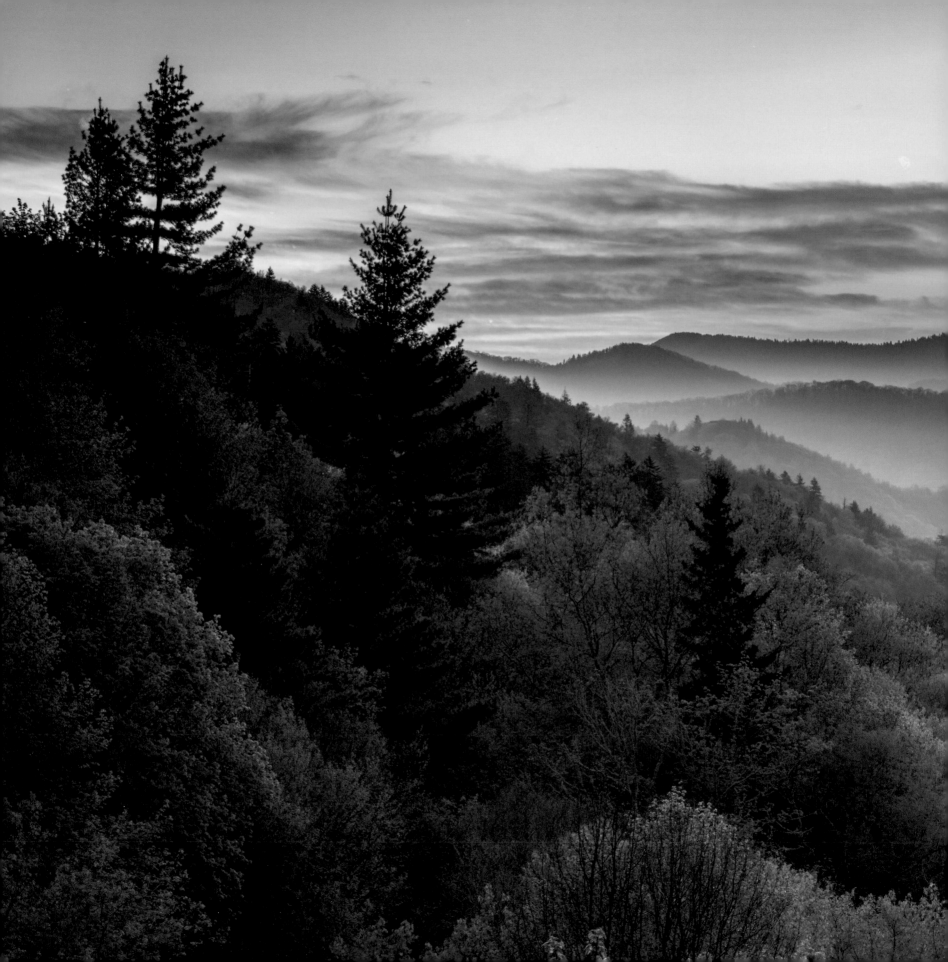

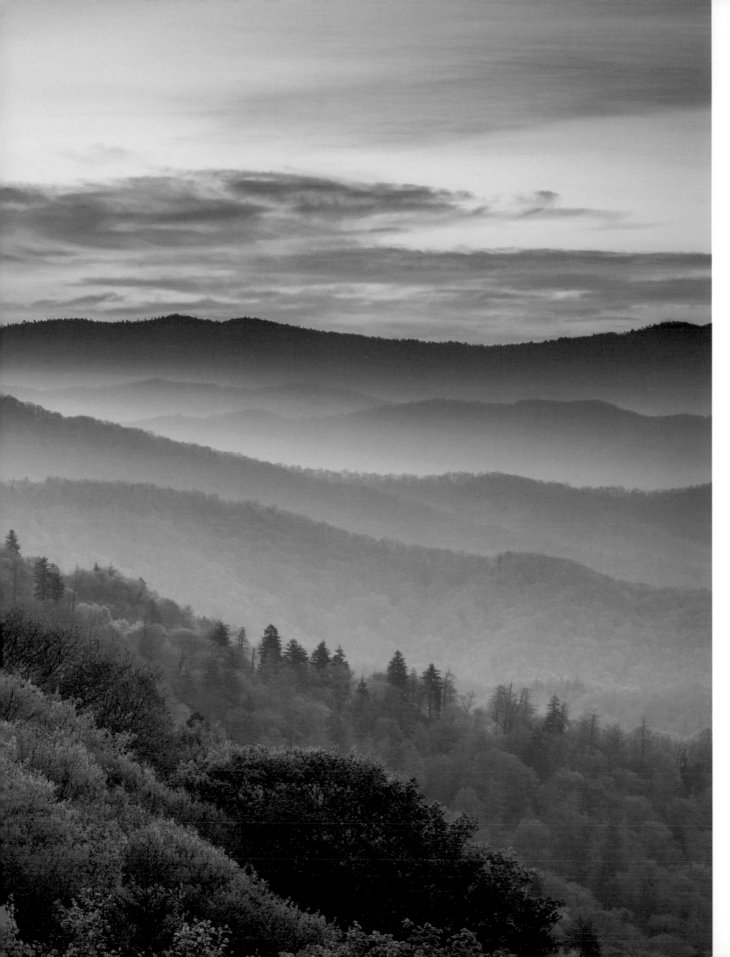

Great Smoky Mountains National Park, an area of over 800 square miles, is home to an astonishing range of plants and animals. The park is home to over 200 species of birds, 80 types of reptiles and amphibians, 66 different mammals, and 50 native fish. Over 1,500 species of flowering plants are found here, including 120 native trees.

Knoxville resident Willis P. Davis first proposed a national park in the Great Smoky Mountains. After visiting the western states in 1923 and touring their preserves, she argued that the mountainous region of her home state was worthy of equal protection. The park was established 11 years later.

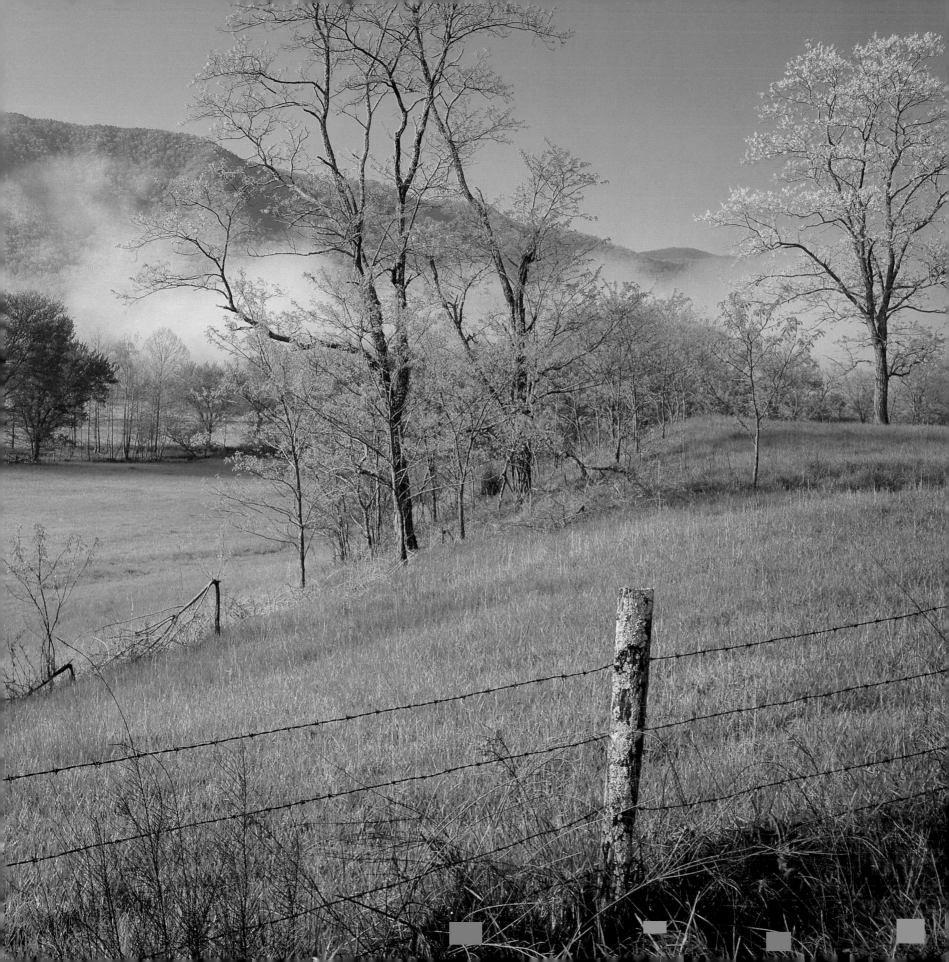

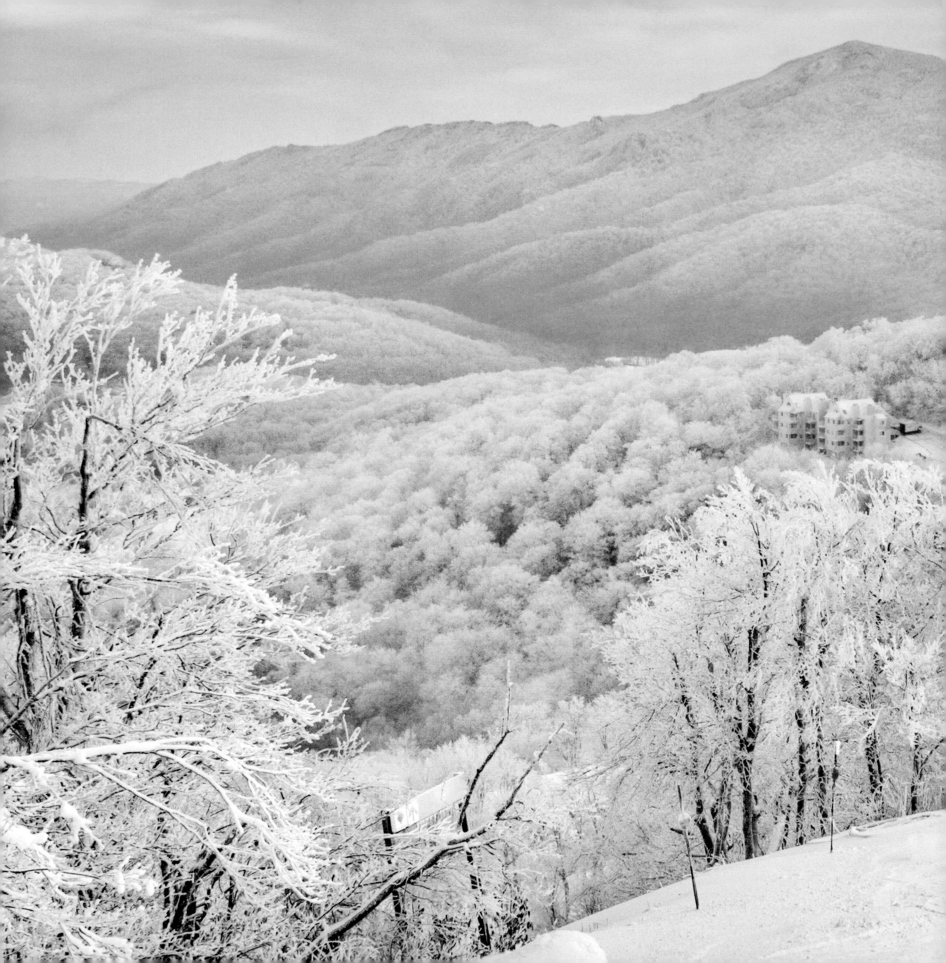

From Sugar Mountain Ski Area and Beech Mountain to Appalachian Ski Mountain and Cataloochee Ski Resort, there are plenty of places to take advantage of North Carolina's sunny winter days and abundant snowfalls.

31

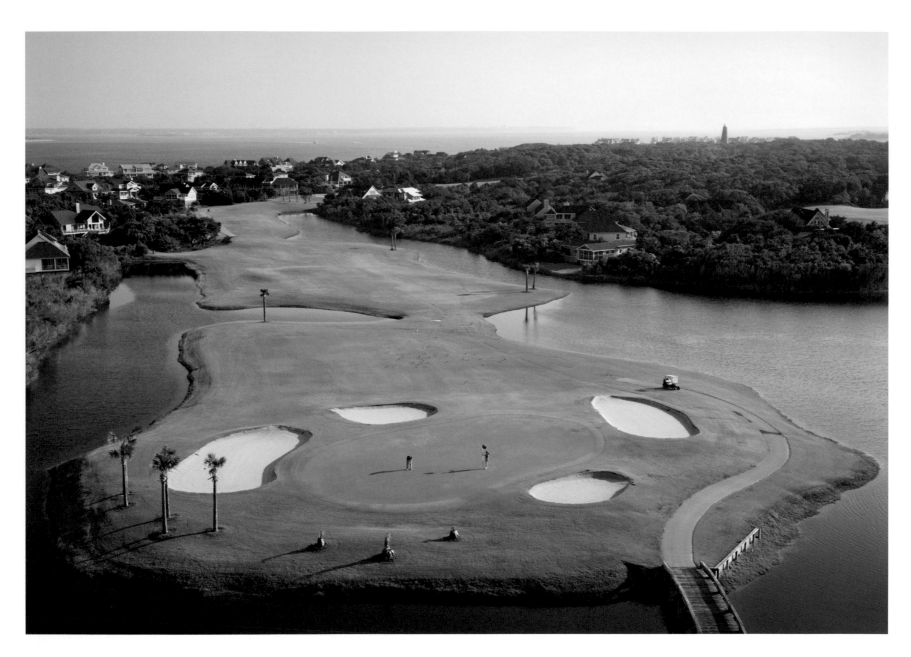

An aerial view of community at Bald Head Island reveals the beautiful private golf course, designed by George Cobb and opened for play in 1974.

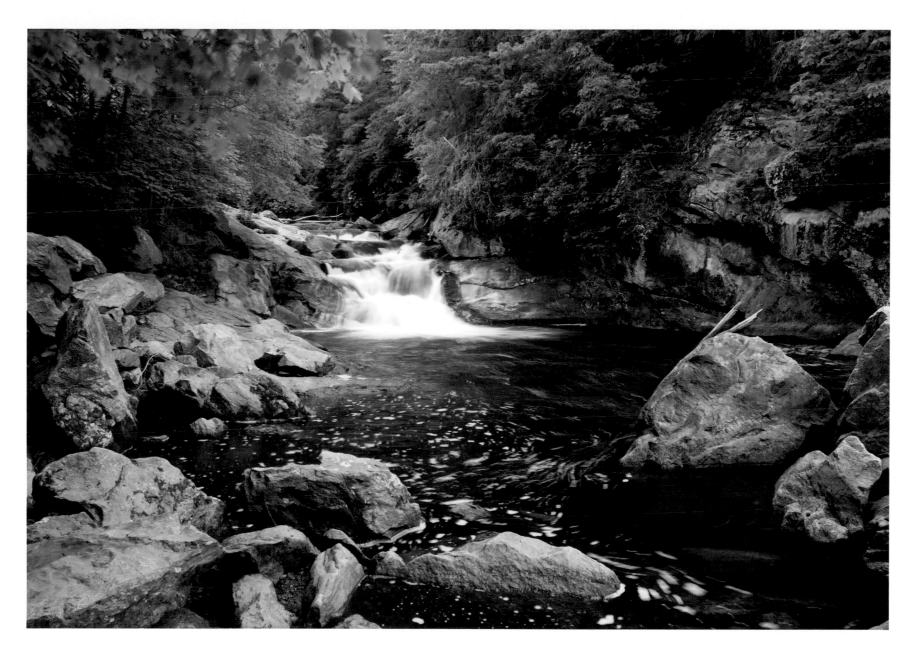

Calm pools of clear water alternate with rushing whitewater rapids as the Nantahala River flows through Nantahala Gorge. This is a favorite destination for kayakers and rafters from across the state.

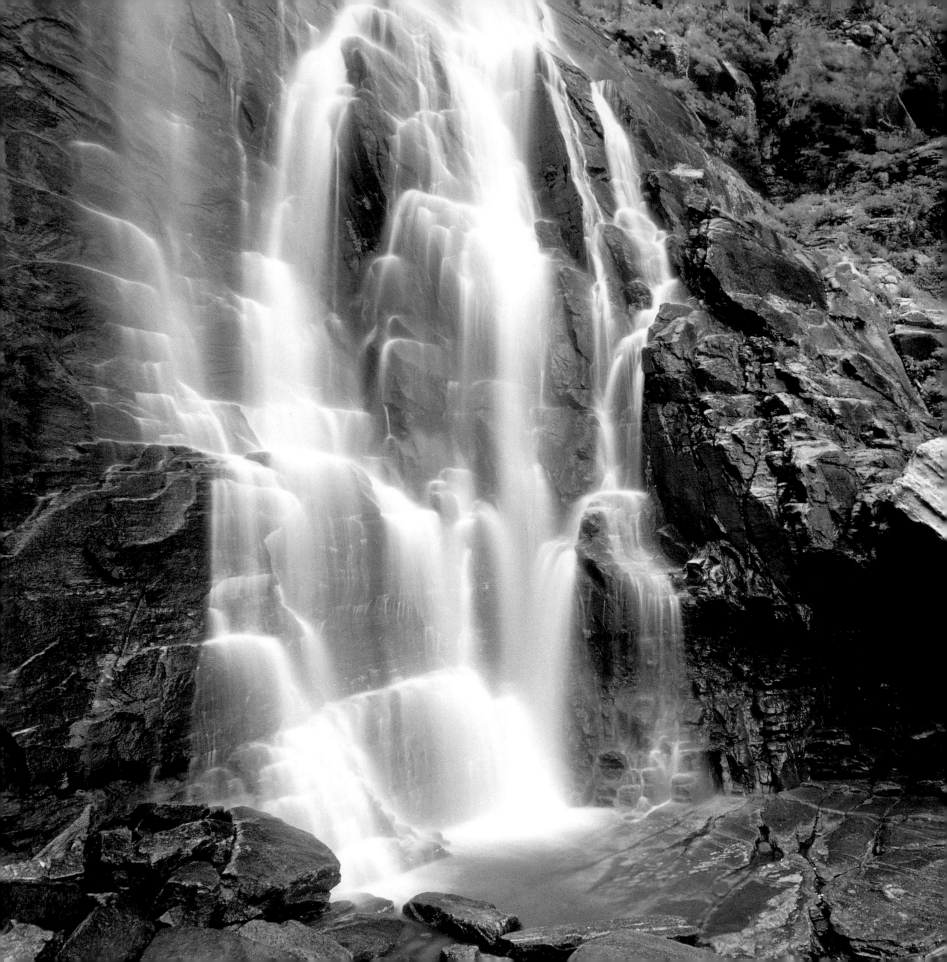

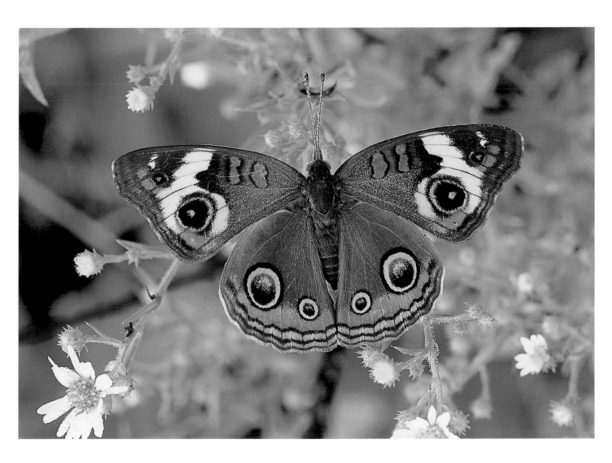

As urban development infringes on the buckeye butterfly's habitat, it relies more and more on domestic plant varieties. It can be spotted in backyard gardens feeding on flower nectar or laying its eggs on snapdragons.

Hickory Nut Falls captivates visitors to Chimney Rock Park, near Asheville. Fed by springs, its waters plunge 404 feet into the Rocky Broad River below.

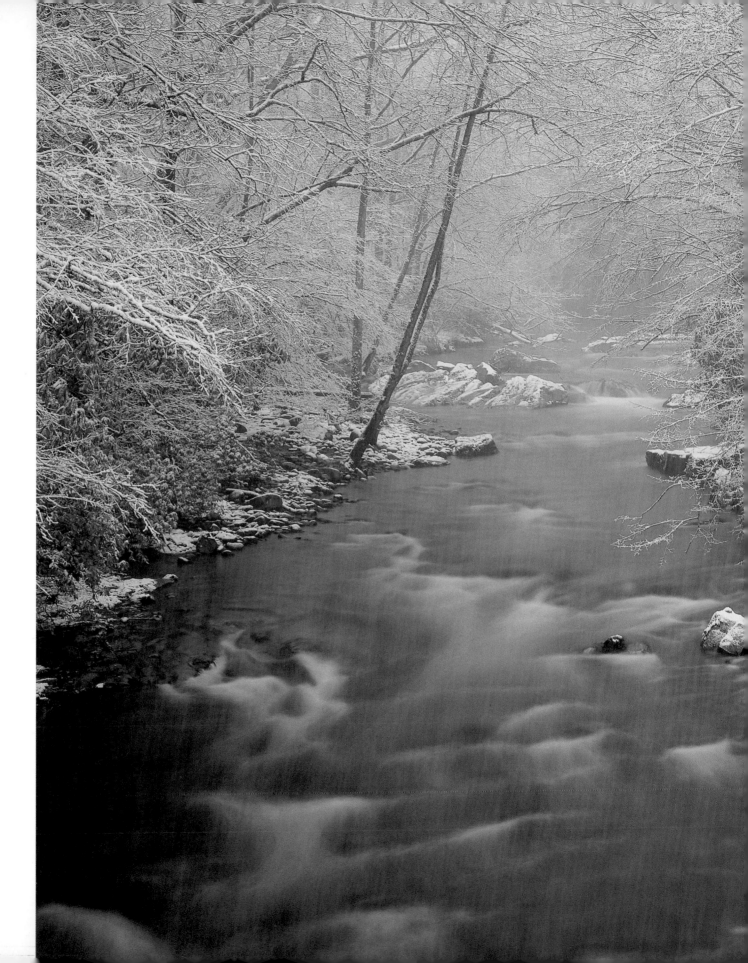

The Great Smoky Mountains hold the record for the greatest snowfall during a single storm— 60 inches fell in Swain County in 1987. Usually, these mountains receive 30 to 40 inches a month throughout the winter.

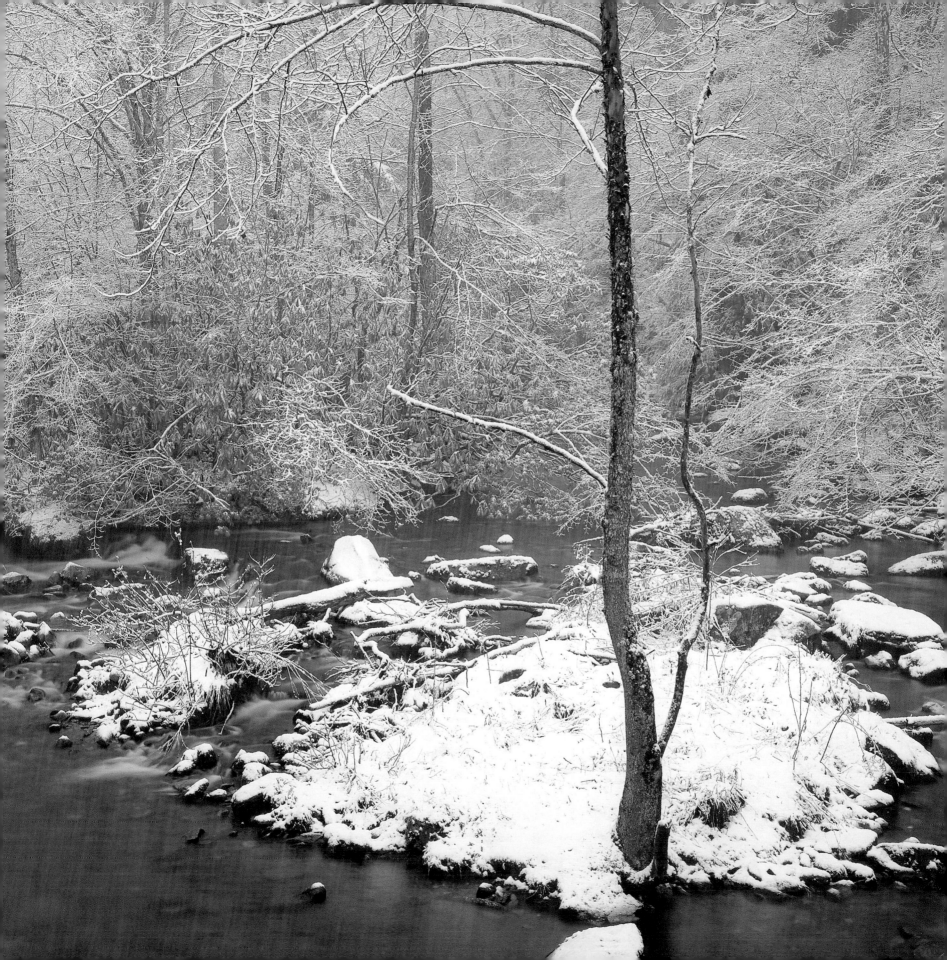

On March 15, 1781, soldiers fighting for American independence clashed with the British army near Guilford, in one of the most intense battles of the Revolutionary War. Historians believe that the losses suffered by the British here ultimately led to their defeat. Today, Guilford Courthouse National Military Park, encompassing over 200 acres, commemorates the battle.

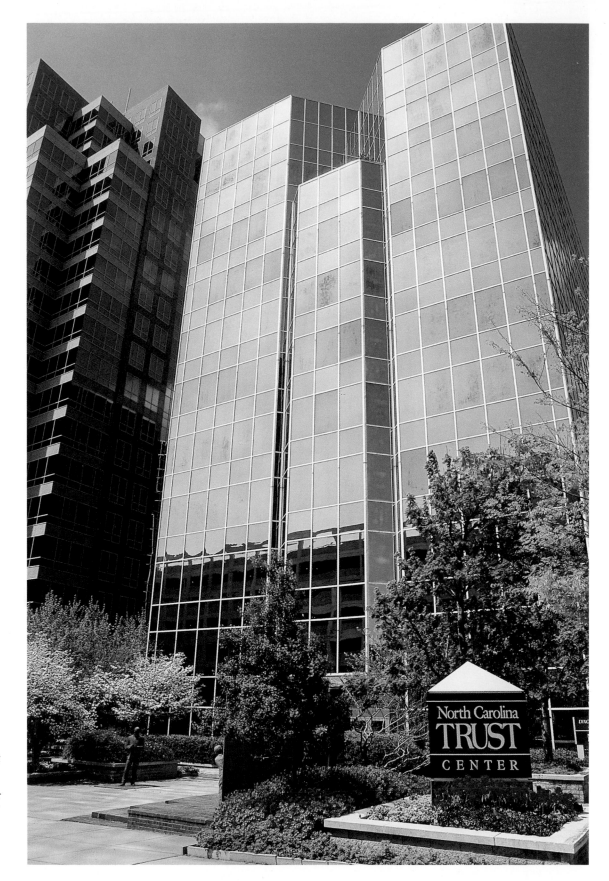

Greensboro is named for General Nathanael Greene, a leader of the American forces during the Revolutionary War. The city is known for its colorful cultural celebrations, among them the African-American Arts and Carolina Lite Blues festivals in spring, the East-ern Music Festival in summer, and the Festival of Lights in winter.

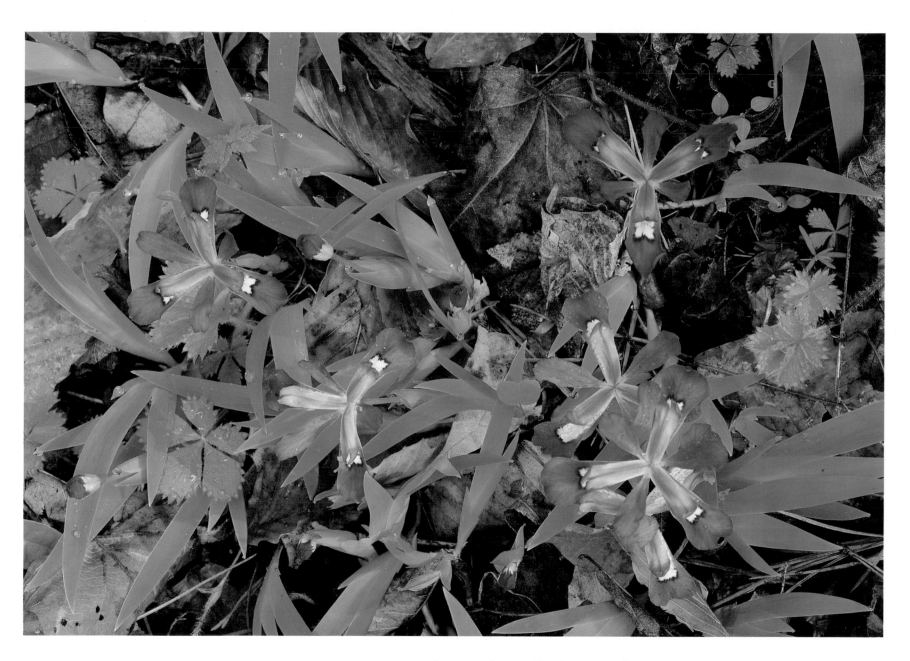

Only 6 inches tall, the dwarf crested iris blooms on shady mountain slopes from Maryland to Georgia. This is just one of more than 10,000 plant and animal species found in North Carolina's mountains.

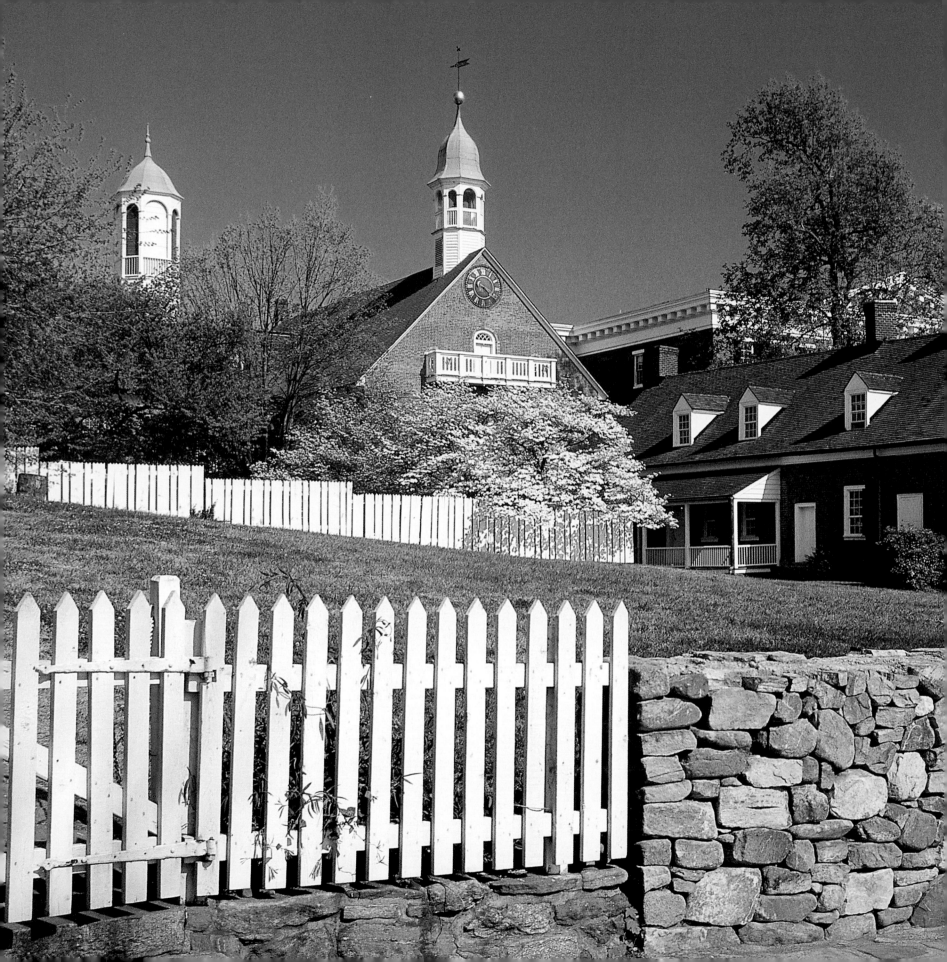

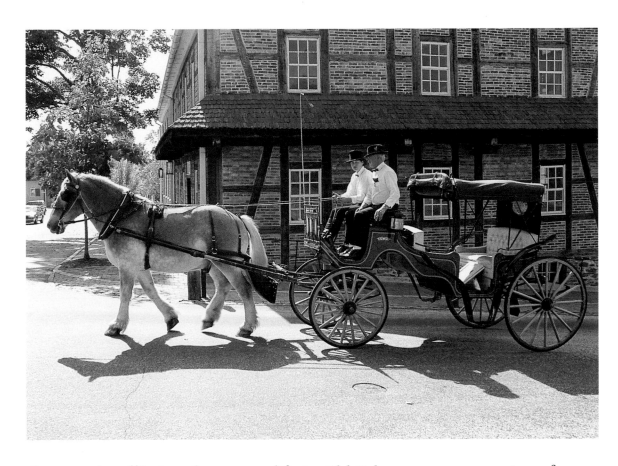

Costumed staff bring the past to life in Old Salem, a reconstruction of an 18th-century community founded by Protestants. Visitors today can tour a log church built in 1823, as well as a museum and gallery.

In 1913, the historic town of Salem joined the Quaker, English, and Scotch-Irish settlers of nearby Winston to found Winston-Salem, billed as a city based on cooperation.

More than 50 log buildings, including a general store, a school, a church, and residences, invite visitors back to the mid-1800s in Hart Square. This picturesque grist mill was moved from another location to become one of the main attractions in the reconstructed village.

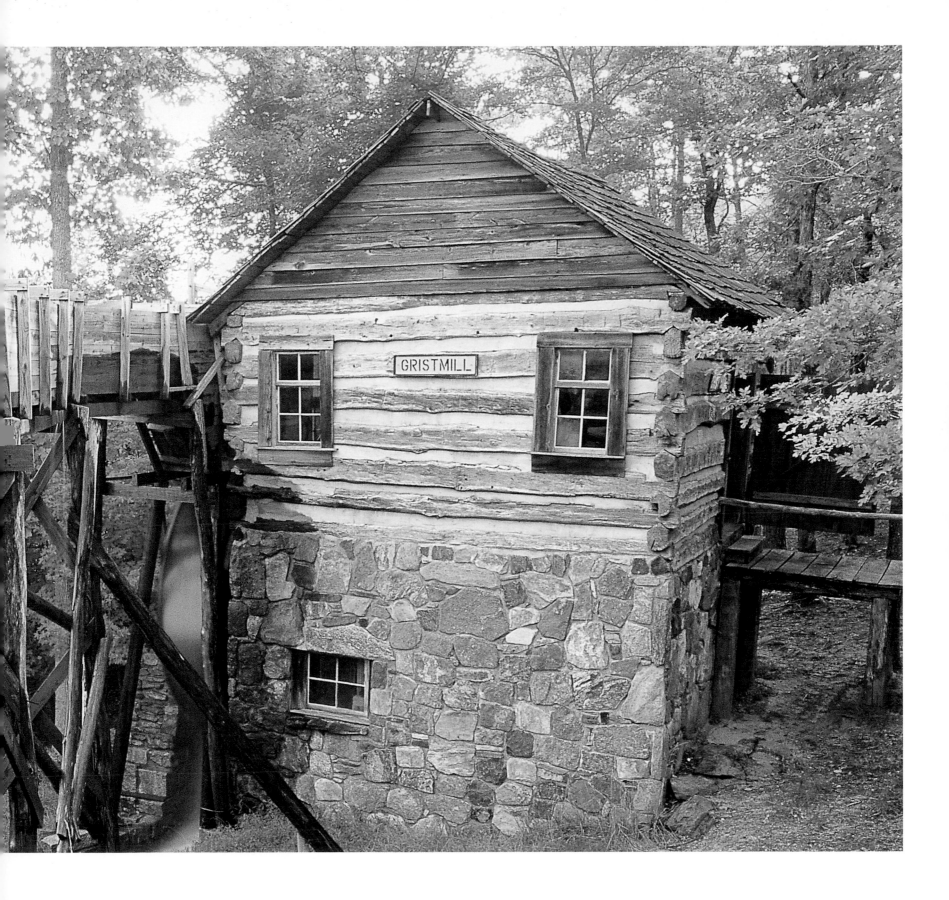

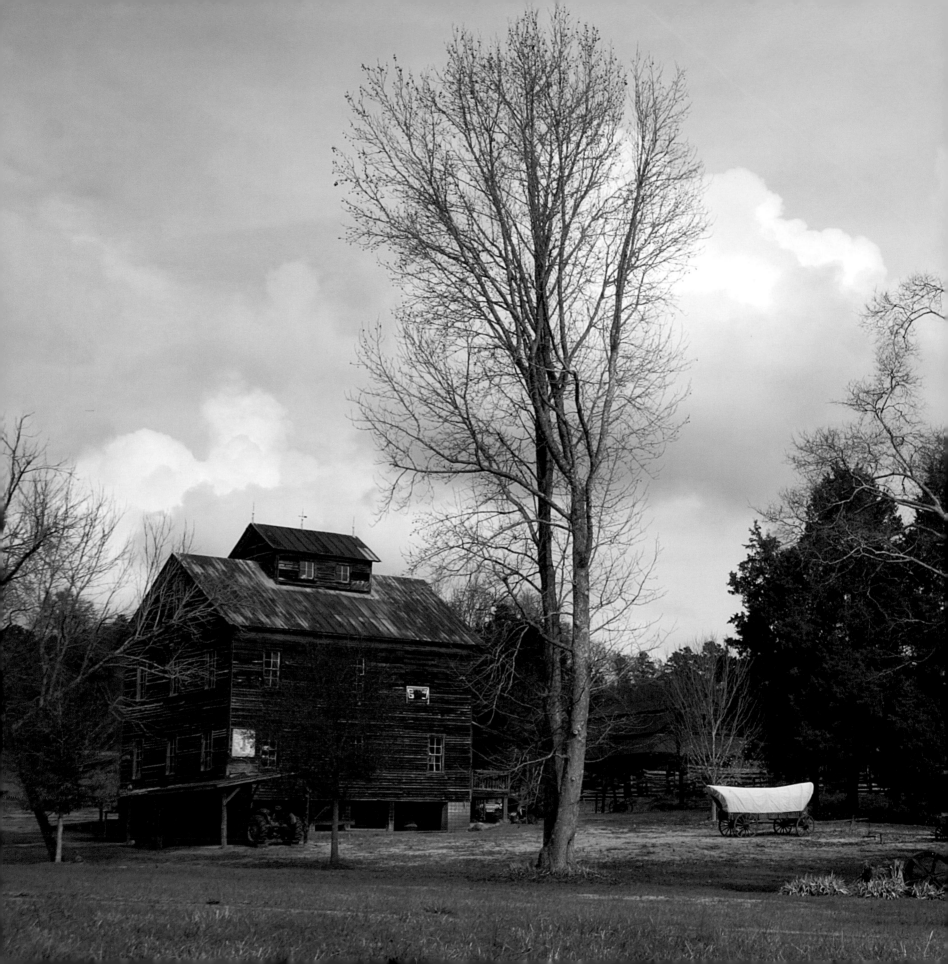

The first major European settlement of North Carolina began after 1663, when King Charles II of England granted most of the region to eight of his sup-porters. It remained in the control of these men and their de-scendants until 1729, when most owners sold their land back to Britain, creating the royal colony of North Carolina.

47

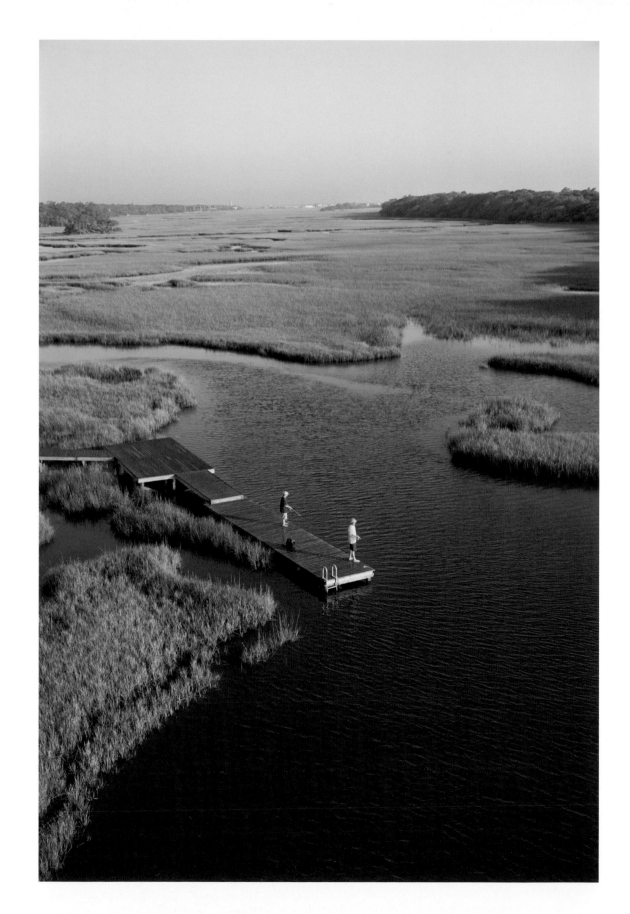

North Carolina has a total of 3,826 square miles of inland water. Among the famous golf courses and riding stables of the affluent Sandhills region, environmental groups strive to protect fragile wetland areas such as this one, home to reptiles, fish, small mammals, and migrating birds.

Where the Blue Ridge and Great Smoky Mountains meet, the city of Asheville is a gateway to outdoor adventure and boasts a revitalized, cosmopolitan downtown, packed with charming cafes, trendy boutiques, art galleries, and antique shops.

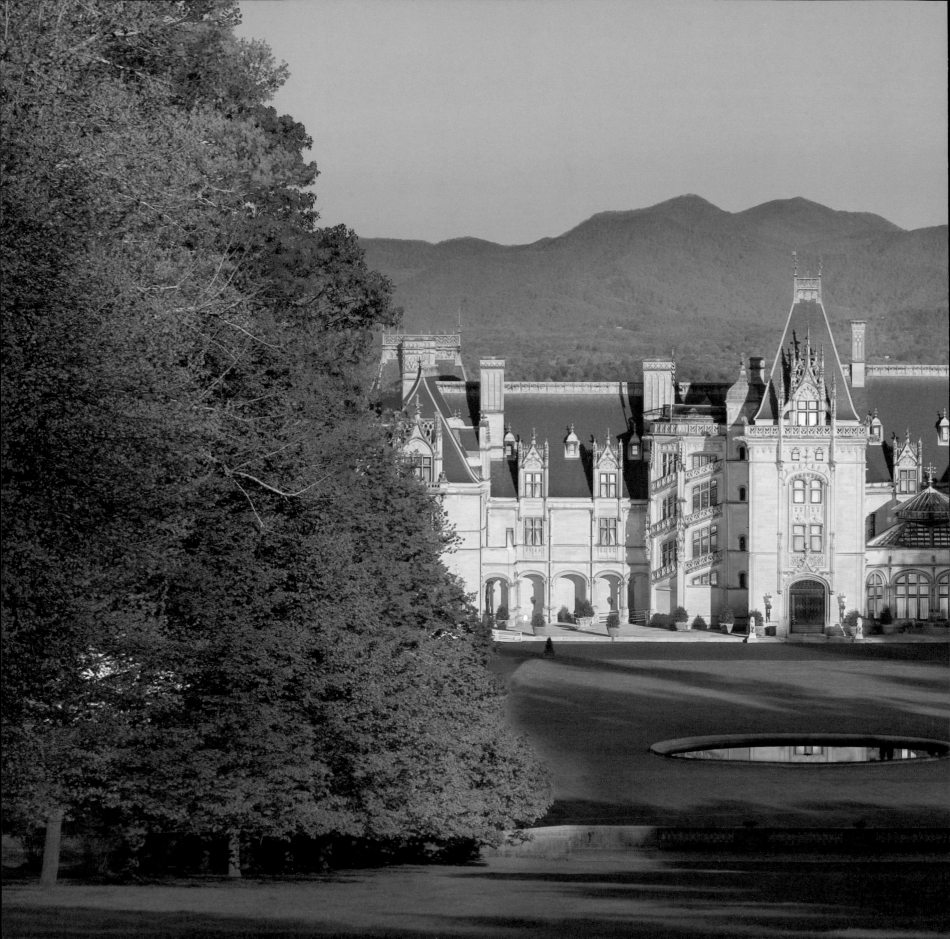

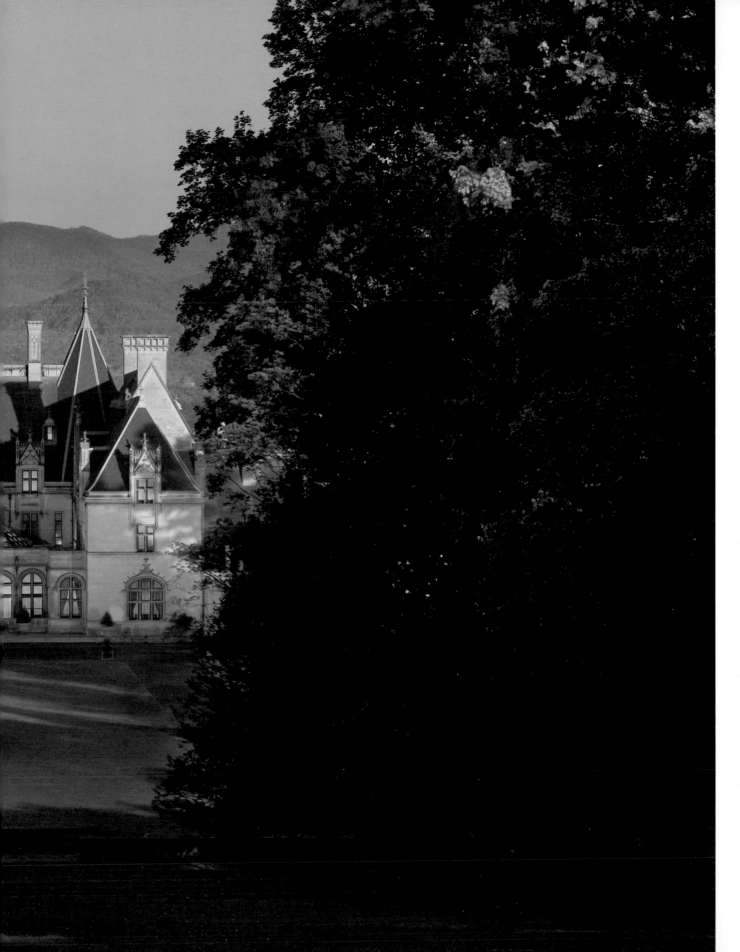

With 255 rooms, Biltmore House is the largest private home in the United States. It was built in the 1800s by George Vanderbilt, grandson of shipping magnate Cornelius Vanderbilt and son of financier William Henry Vanderbilt. The home is still owned by a descendant of the family.

Soldiers from North Carolina were prominent in dozens of major Civil War battles, including Pickett's Charge at Gettysburg. In front of the Old County Courthouse in downtown Durham stands a memorial of an armed and uniformed soldier. Inscribed upon the granite tower are the Confederate seal and the phrase "The Boys Who Wore the Gray."

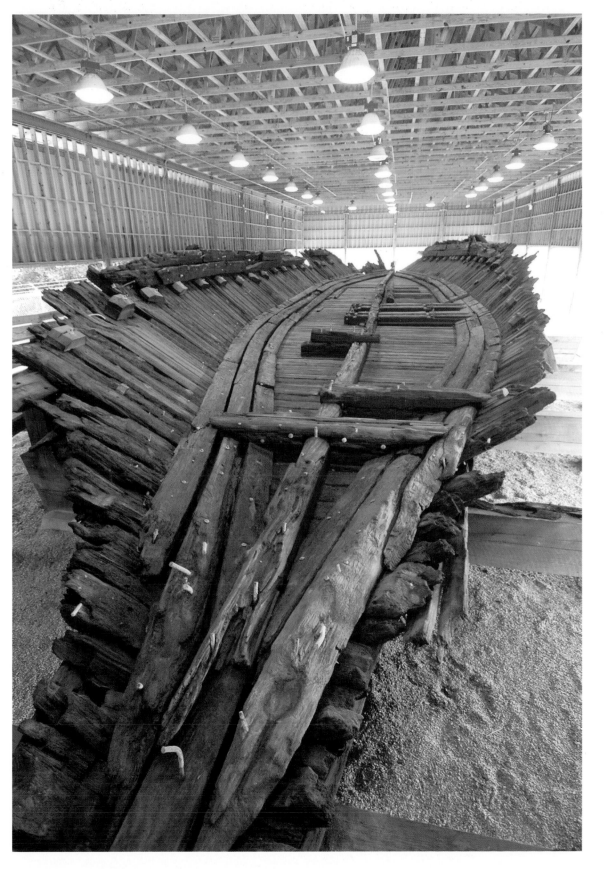

The CSS Neuse, a product of the Confederate Navy's attempt to regain control of New Bern during the Civil War, was one of 22 ironclad gunboats constructed and commissioned by the Confederate government. The hull remnants are now on display at the CSS Neuse State Historic Site in Kinston.

In 1898, under the patronage of George Vanderbilt and on the lands of the Biltmore Estate, German forester Carl Schenck founded the Biltmore Forest School, a year-long program of study and practical work. Today, the Cradle of Forestry welcomes visitors to the site of the school and helps to educate the public about the history and development of forestry practices.

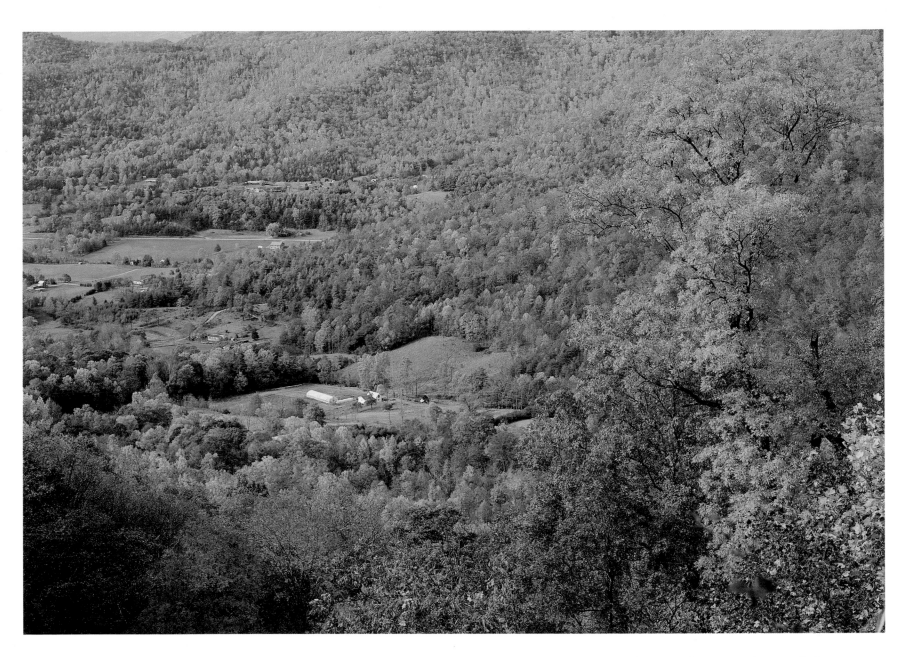

The Montreat Conference Center, an event facility for members of the Presbyterian Church, encompasses 4,000 acres. While some land is dedicated to hotels, campsites, auditoriums, and recreation facilities, over 2,000 acres are pristine wilderness, designated a Natural Heritage Area by the state.

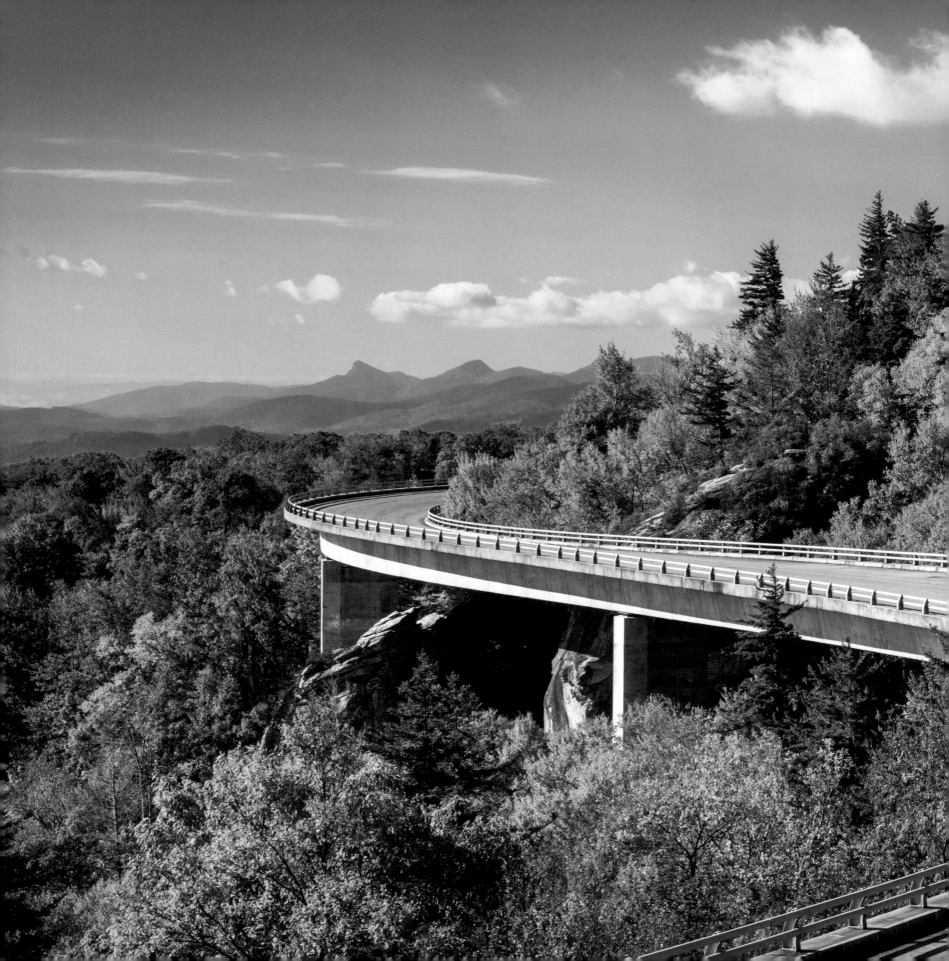

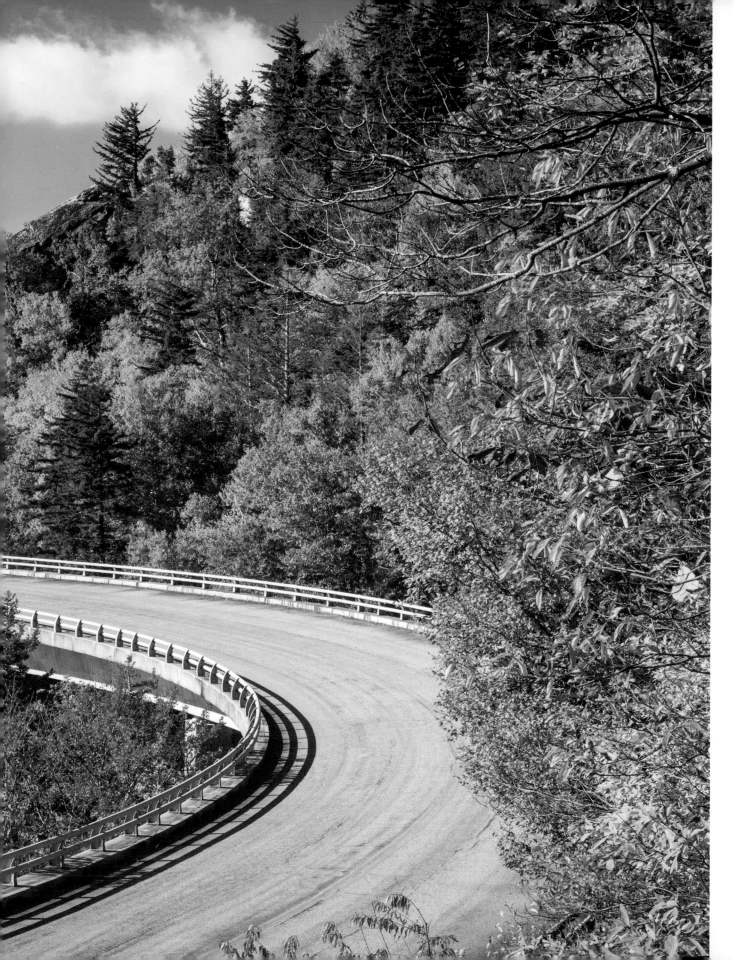

At more than 4,000 feet above sea level, the engineers who designed the Blue Ridge Parkway had to find a way to lead travelers around Grandfather Mountain without damaging the land. The result was the Linn Cove Viaduct. The world's most complicated concrete bridge, it is 1,243 feet long and cost $10 million to build.

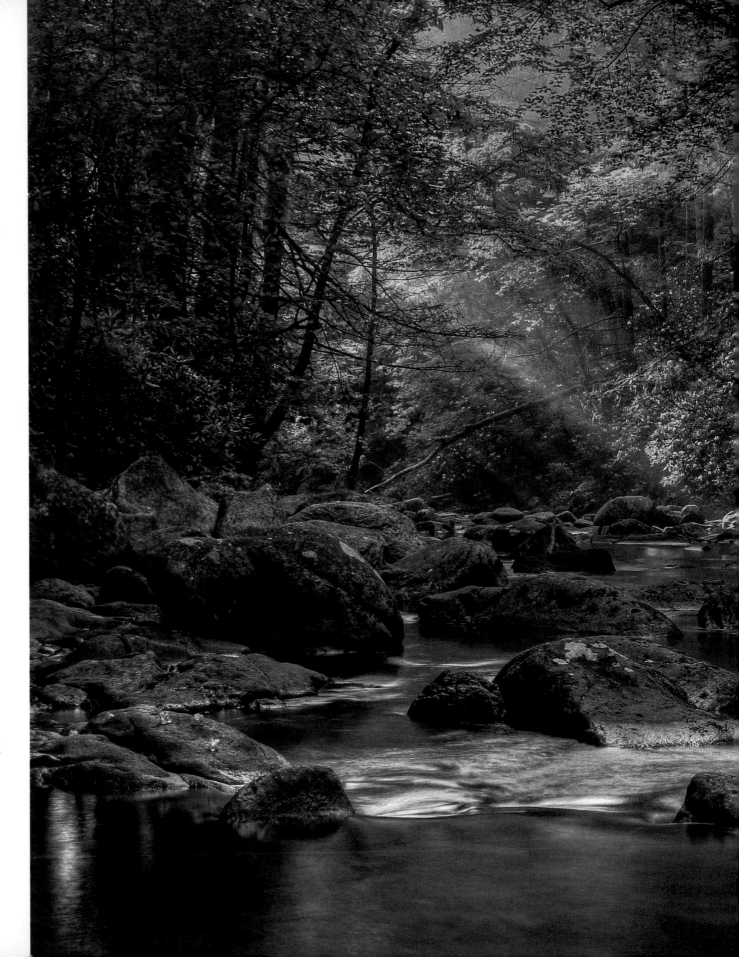

Much of the land now included in Pisgah National Forest was once the property of George Vanderbilt, and was sold to the government after his death in 1914. The forest draws its name from Mount Pisgah, which in turn is named for the legendary mountain peak where Moses first glimpsed the promised land.

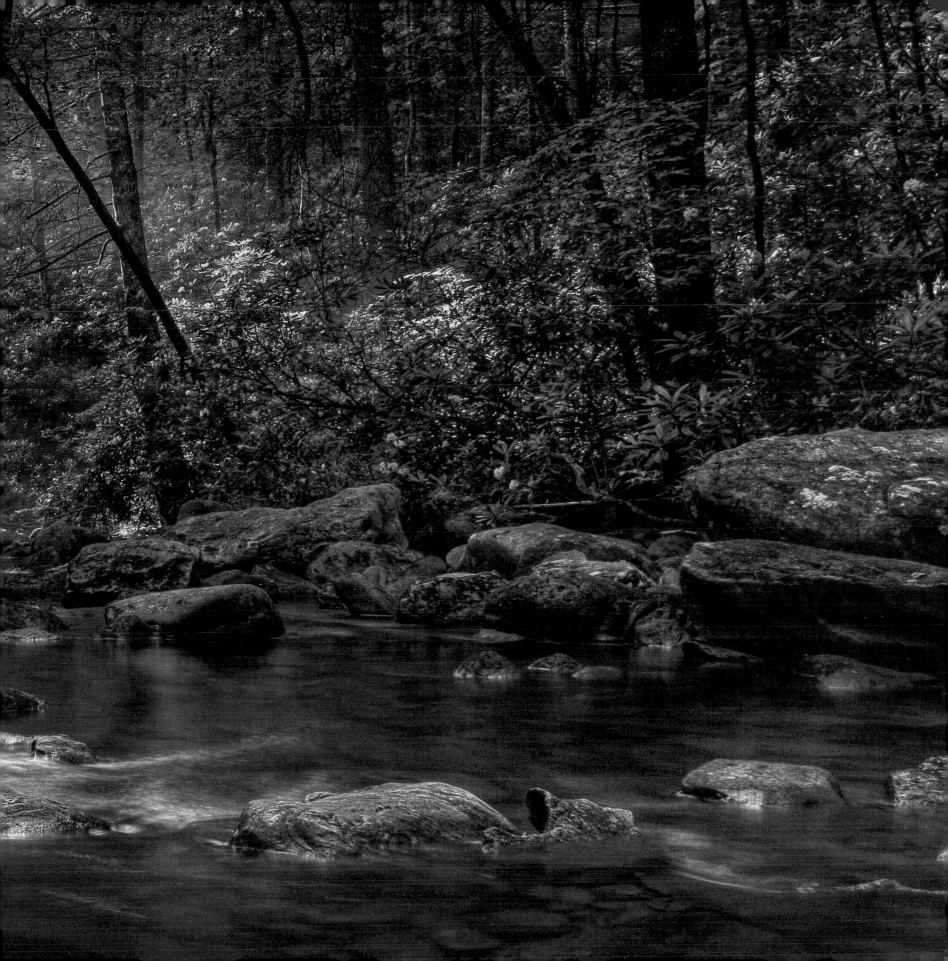

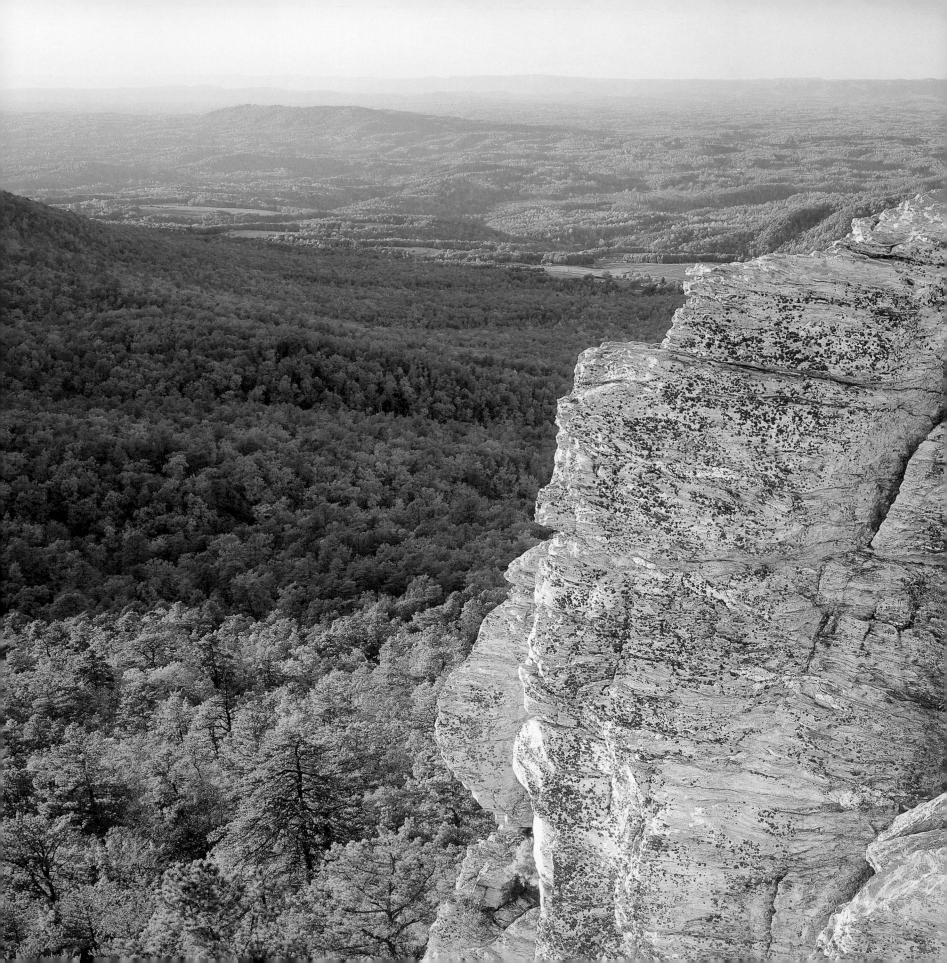

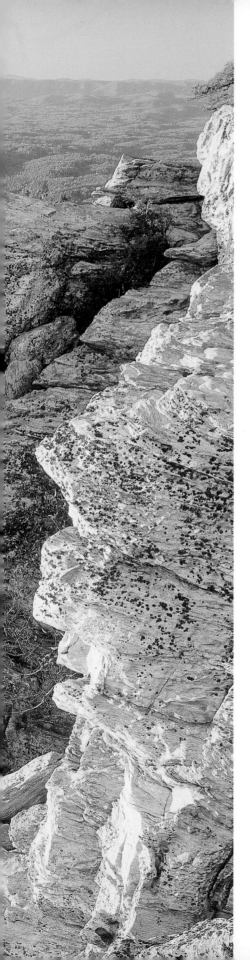

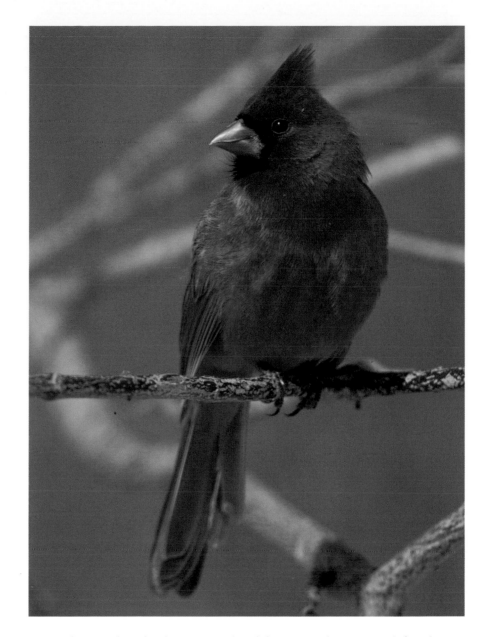

A male cardinal, distinguished by its vibrant red feathers and black face, waits out a storm. North Carolina's state bird can be seen in the most remote areas of the state, as well as at backyard bird feeders in urban areas.

Travelers can often spot rock climbers clinging to the cliff faces at Hanging Rock State Park, where a two-mile-long series of precipices drop up to 400 feet. About 300 mountain plant species can be found within the park.

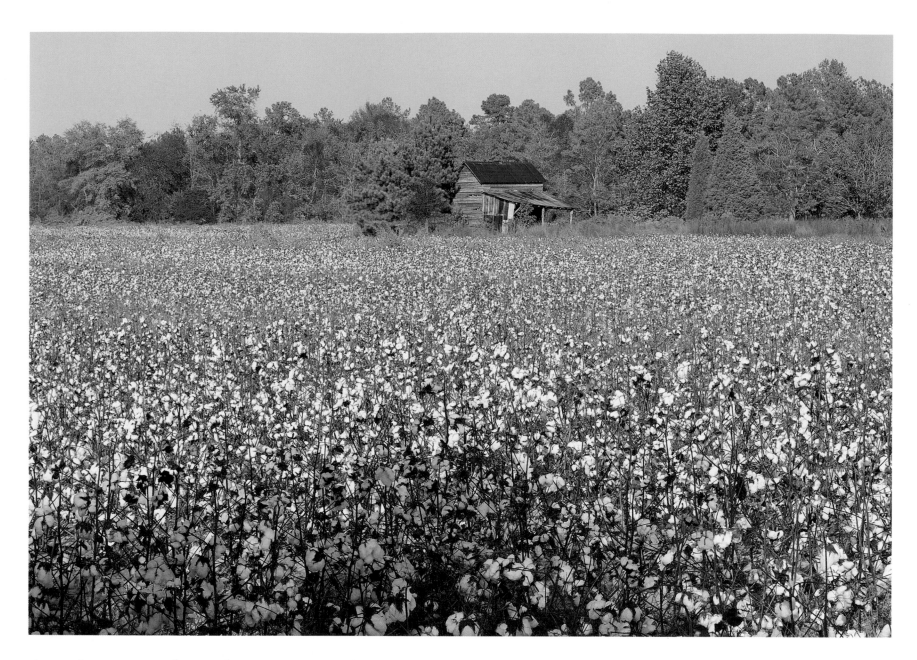

Agriculture is North Carolina's primary industry. Crops range from
these sprawling fields of cotton to more than 4 billion pounds per year
of sweet potatoes, recently proclaimed the state's official vegetable.

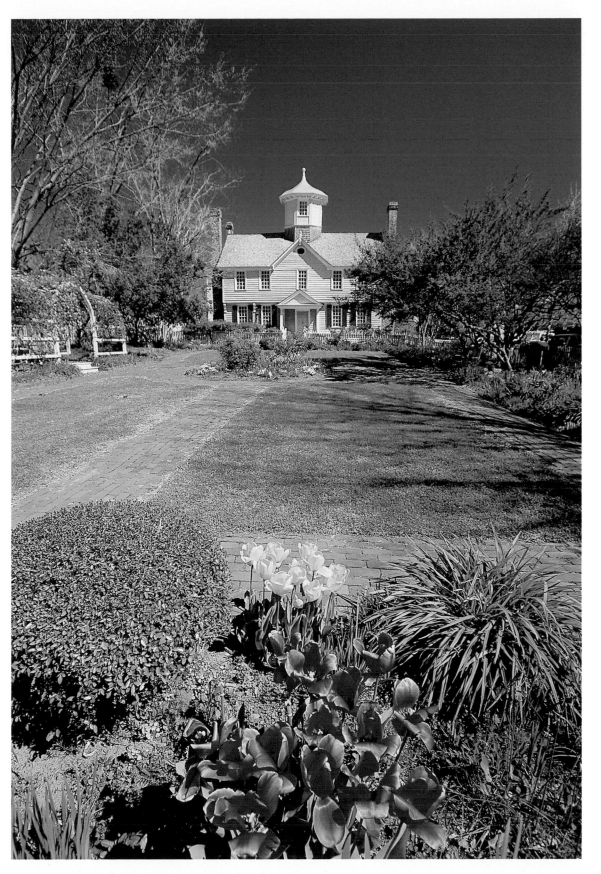

Edenton, North Carolina's first permanent, non-Native settlement, is billed as the South's prettiest small town. Founded in 1715 as The Towne on Queen Anne's Creek, Edenton has also been known as Ye Towne on Mattercommack Creek and the Port of Roanoke during its 300-year history.

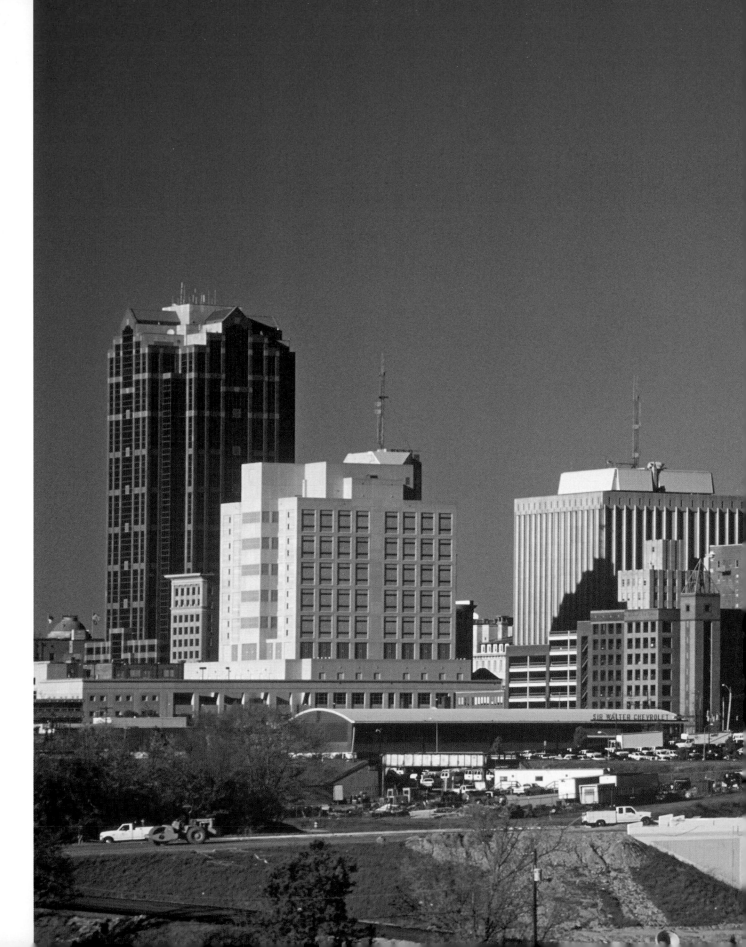

Raleigh is named in honor of Sir Walter Raleigh who, although he never visited America, helped to establish the British colonies here in the 16th century. Raleigh was named the capital of North Carolina in 1792.

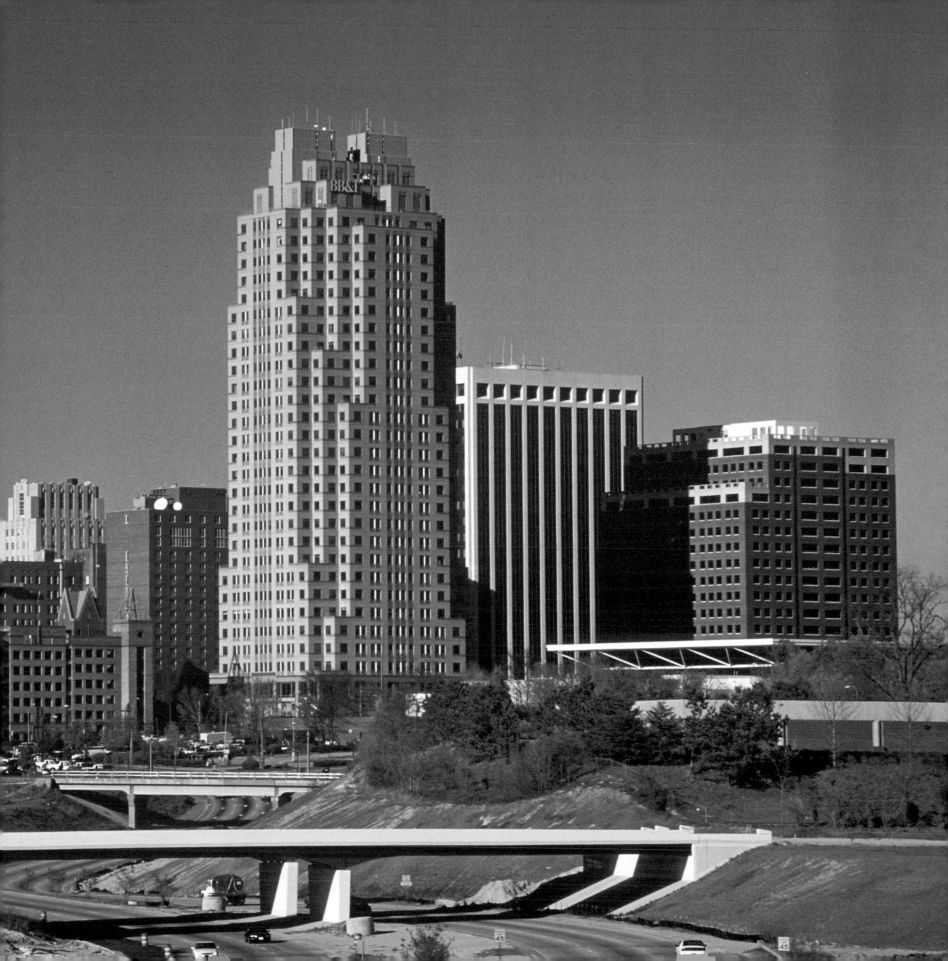

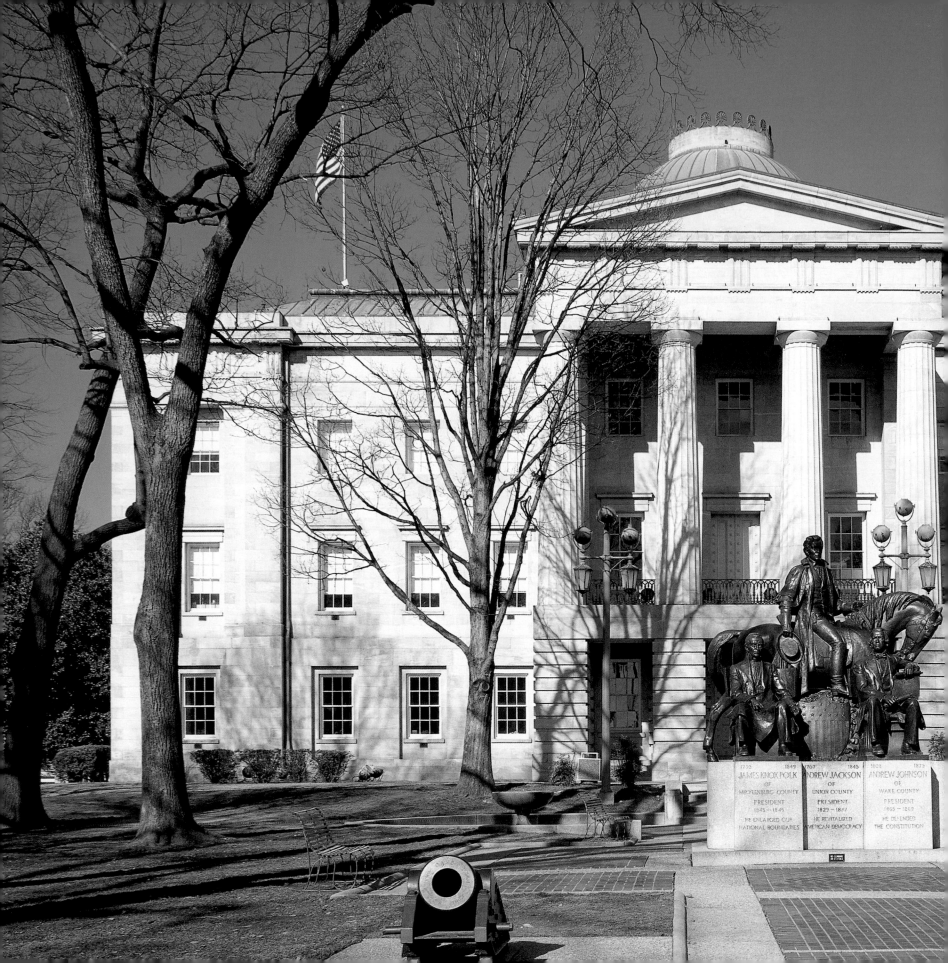

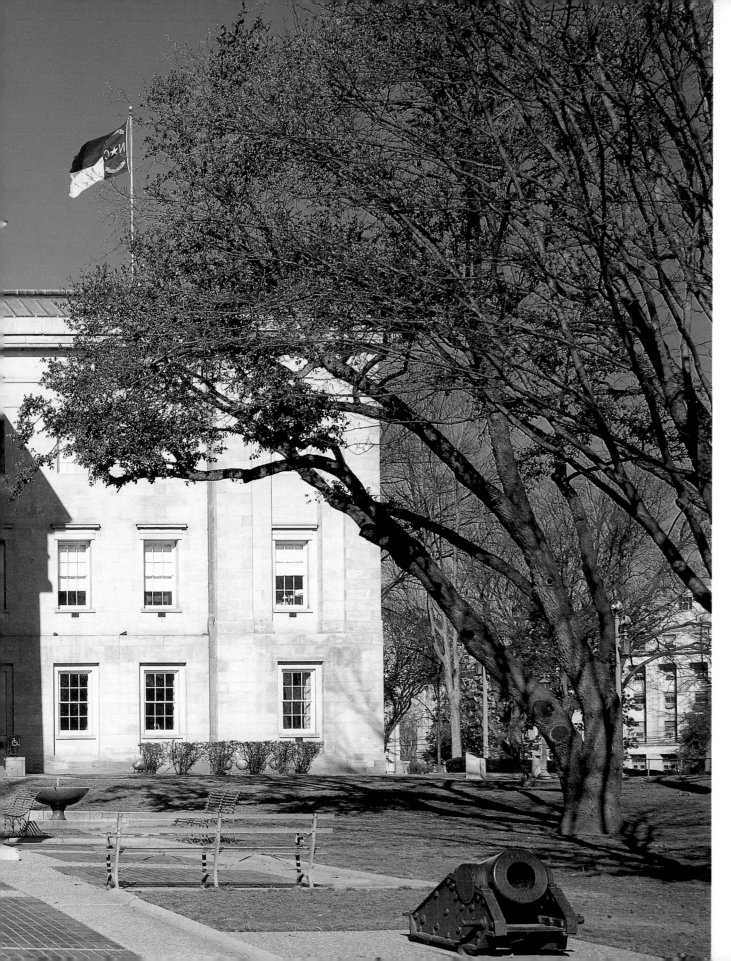

The State Capitol was built on Union Square—locally known as Capitol Square—in 1840, replacing an earlier state house that was destroyed by fire. The site was chosen in 1788 for its location near the estate of Isaac Hunter, a powerful plantation owner at the time. A new city soon grew up around it.

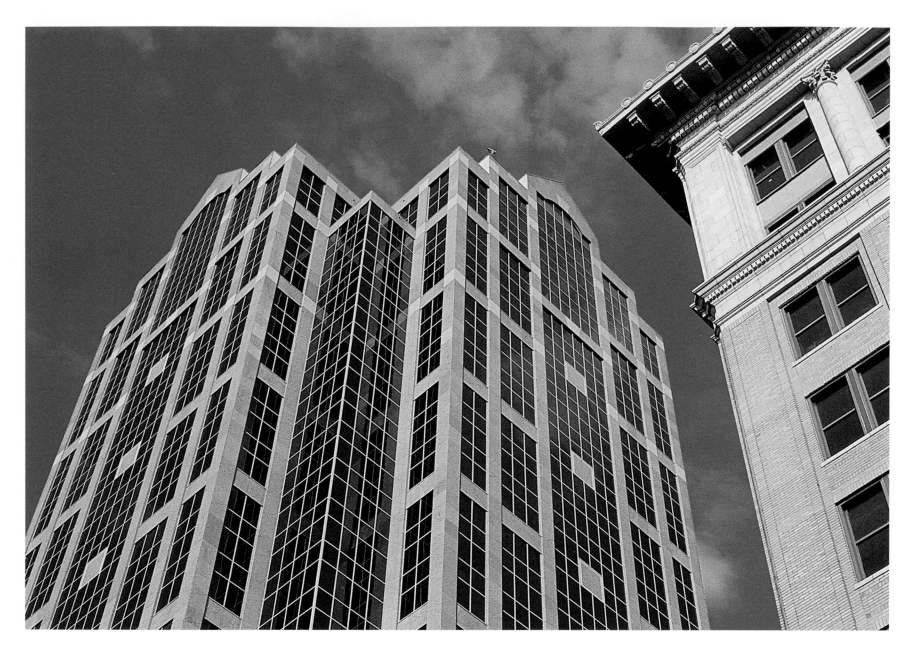

More than 423,000 people live in Raleigh, one of the fastest-growing cities in the nation. Along with a thriving business sector, the state government is a primary employer, and the six post-secondary institutions within the city provide education, employment, and cultural opportunities.

Founded in 1865 as the first Black university in the south, Shaw University in Raleigh now offers 26 degree programs to 2,800 students of all ethnic backgrounds. The university is known for its emphasis on social programs; since 1993, all students have been required to complete courses in ethics and values.

For more than 50 years, the North Carolina Azalea Festival has been bringing garden lovers from across the state to the homes and parks of Wilmington. It includes tours of gardens and private homes, concerts, a street fair, a parade, and other events.

70

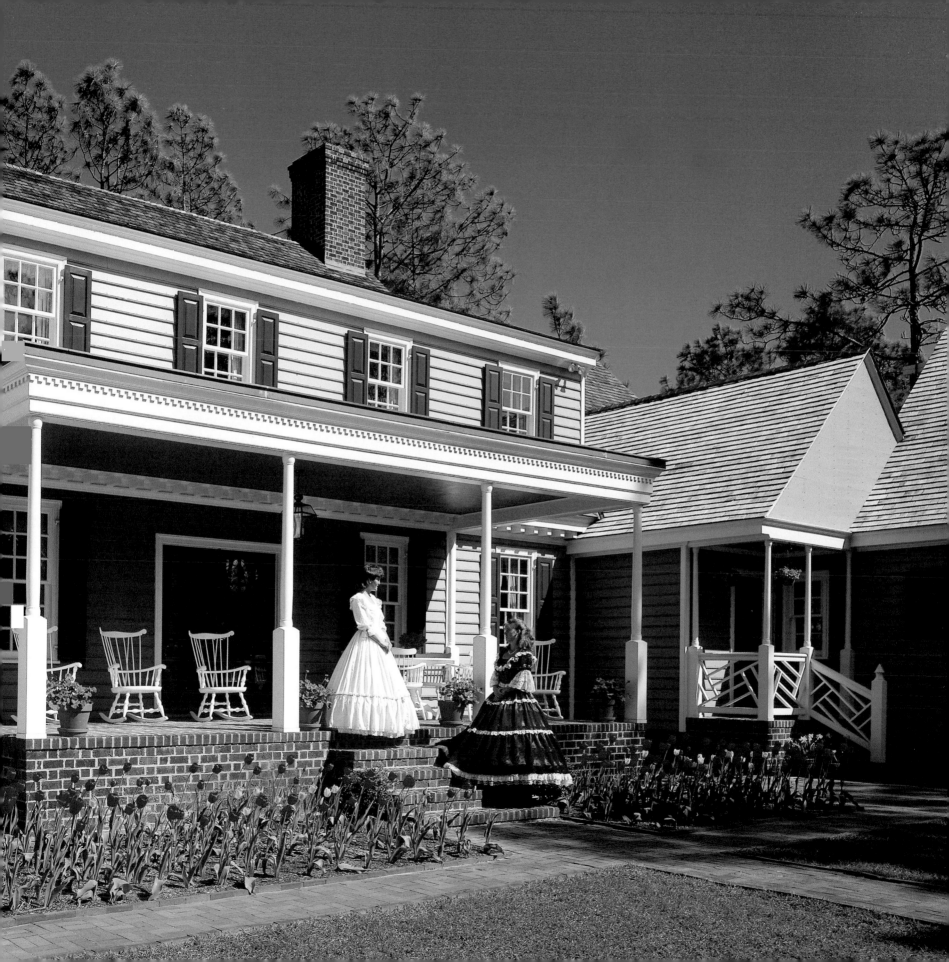

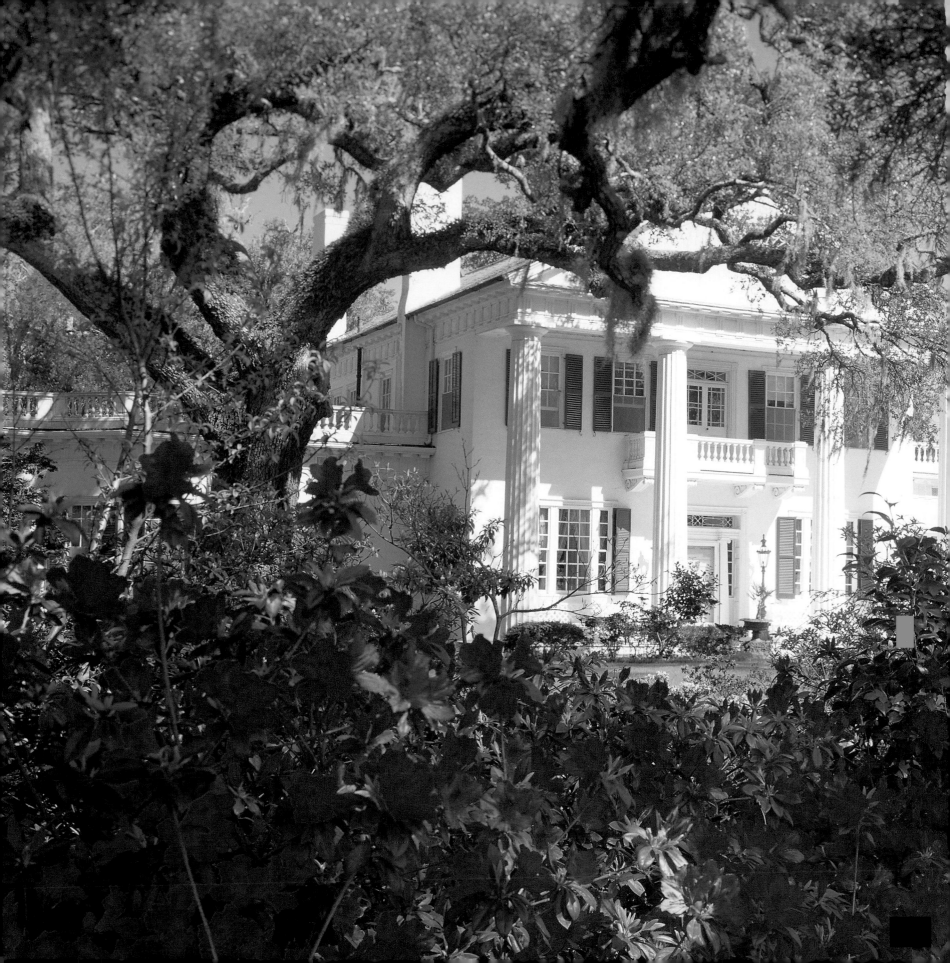

Wilmington's local history is rich with stories of "King" Roger Moore, who arrived with his brother Colonel Maurice Moore to settle the area in the 18th century. Known for decimating a local Native group when they burned his home, Roger Moore is also remembered for founding the lush Orton Plantation, with its abundant rice crops, in 1725.

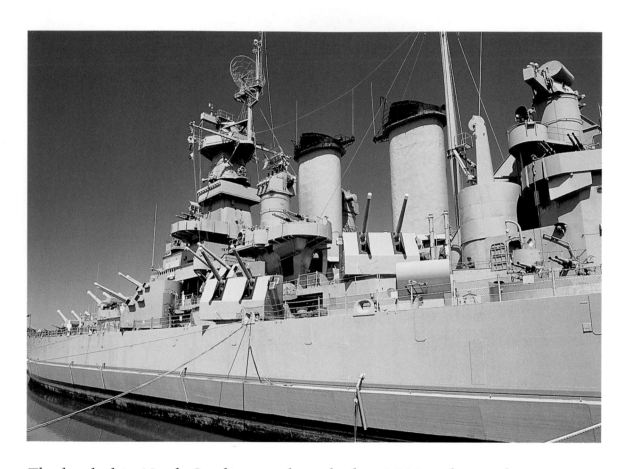

The battleship *North Carolina* was launched in 1940 and served in the Pacific during World War II. In 1962, the vessel was anchored in Wilmington and converted into a war memorial.

Built in 1842, the Old Market House in Fayetteville, North Carolina's fourth-largest city, has served as a public market, library, church, town hall, fire station, and museum and is now a national historic landmark.

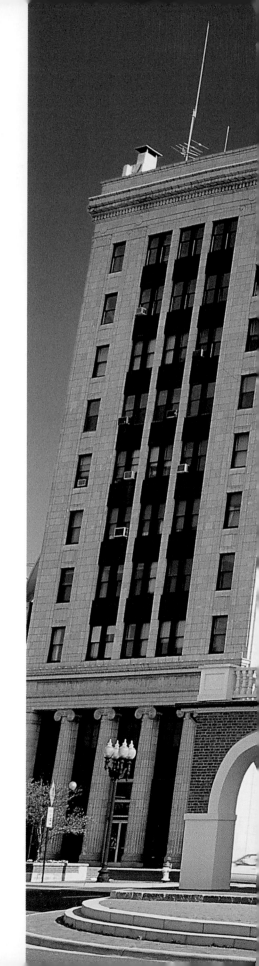

The Cape Fear River is aptly named. Storms churn the water into massive waves that strike fear in even the most experienced seafarers. The Spanish vessel of Lucas Vasquez de Allyon was lost here in 1526, and many have followed since.

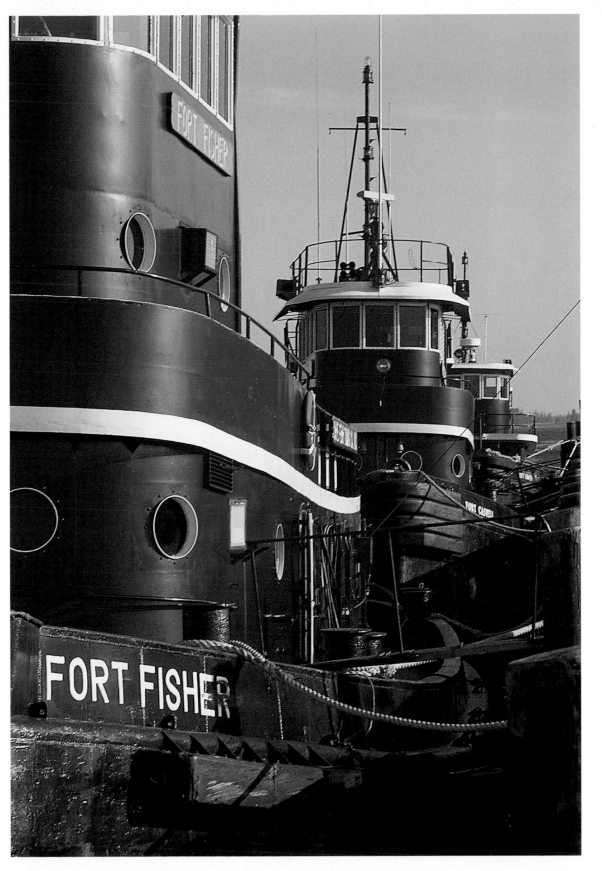

Founded on the banks of the Cape Fear River in 1729, Wilmington was once the largest city in North Carolina. Its bustling port welcomed new immigrants and shipped crops and goods. Though its status as a port has declined, visitors flock to the city for its historic architecture and the nearby beaches.

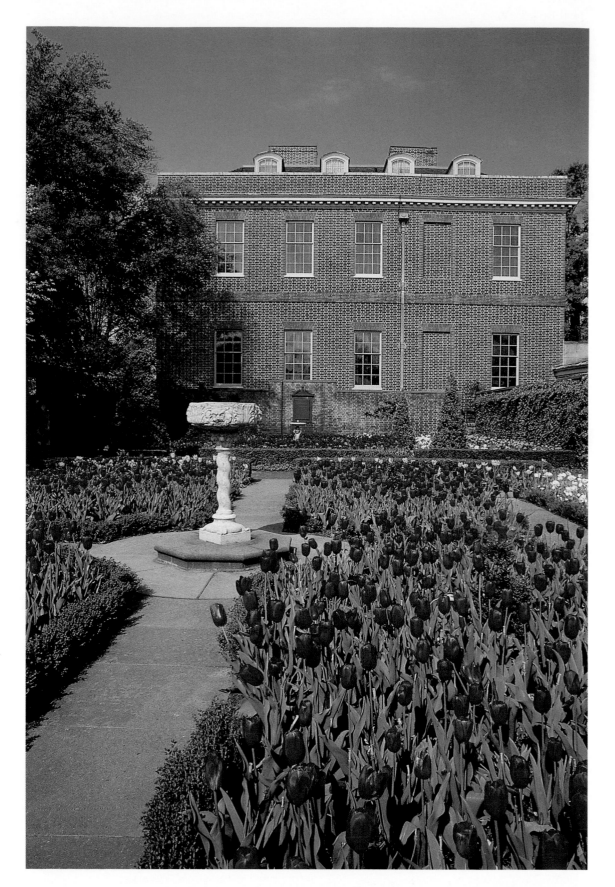

Built in 1770 by British Governor William Tryon, Tryon Palace served as capitol of the Colony of North Carolina and then as capitol of the independent State of North Carolina. The original mansion was destroyed by fire in 1798 but the restored palace, built from the original plans, offers a glimpse of North Carolina's history.

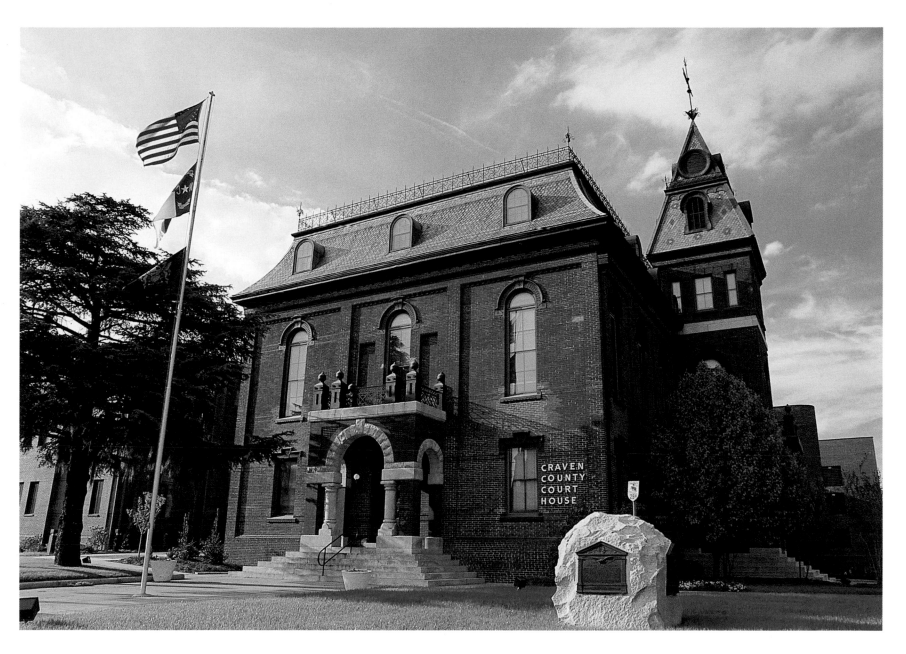

New Bern was settled in 1710 when German and Swiss immigrants purchased the land from the local Native people. Historic architecture, such as this courthouse, is just one of the attractions that draw sightseers. Pepsi Cola was invented in New Bern in 1898.

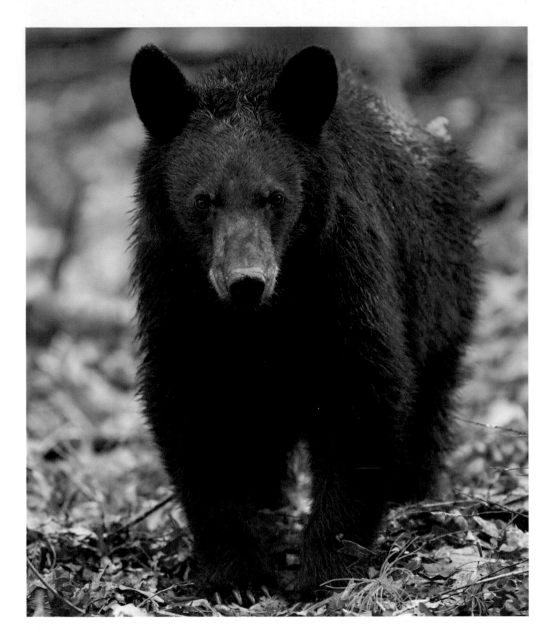

The American Black Bear is the only bear species found in North Carolina. In the mid-1900s the black bear was restricted to remote areas. Today, through successful wildlife management, the black bear is found in nearly 60% of the total land area in North Carolina

Alligators and woodpeckers are some of the most common inhabitants of the Alligator River National Wildlife Refuge. In 1986, two years after its establishment, the refuge became home to a pack of endangered red wolves, some of only 300 that have survived loss of habitat, hunting, and cross-breeding.

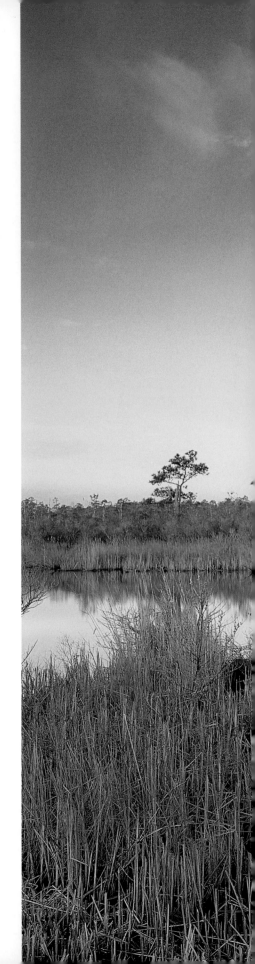

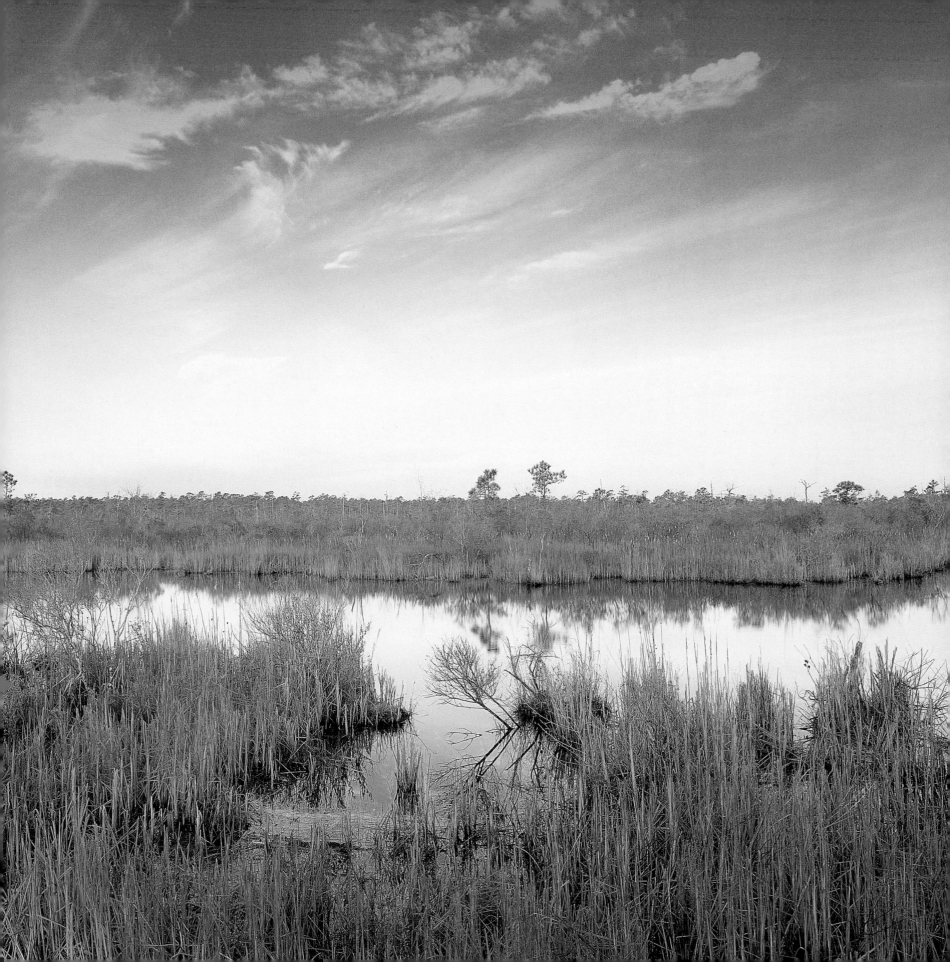

Tourist vessels and fishing boats now ply the waters off North Carolina's coast, but this was once the domain of the pirate Edward Teach—Blackbeard. With a fast ship, 40 cannons, and the fiercest reputation on the high seas, Blackbeard terrorized shipping vessels and outwitted the British Navy until he was captured and killed in 1718.

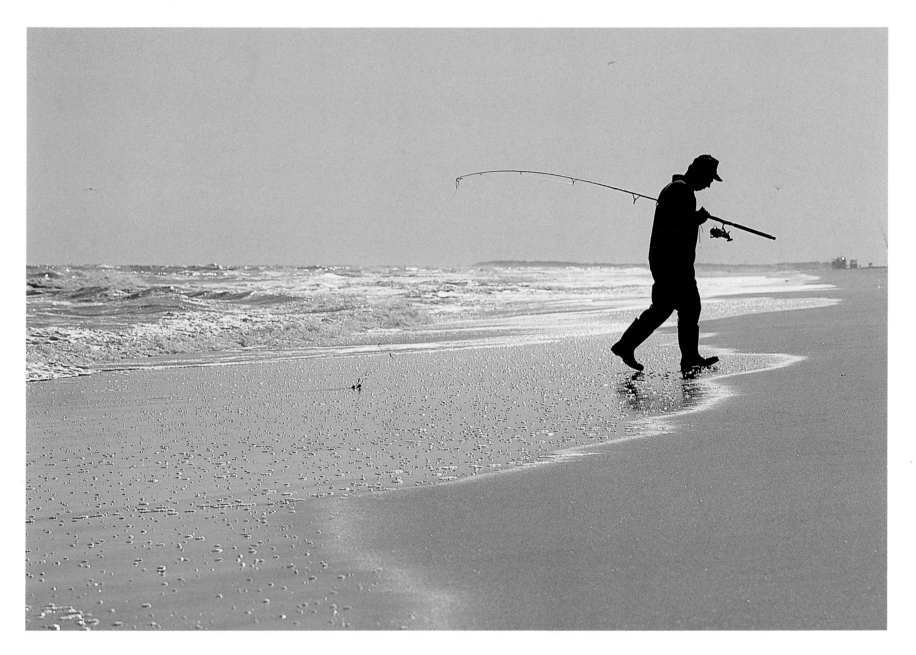

The Outer Banks are a string of barrier islands along North Carolina's coast, protecting the mainland from the ravages of the Atlantic Ocean. Cape Hatteras National Seashore protects the beaches, headlands, wetlands, and woods of these islands.

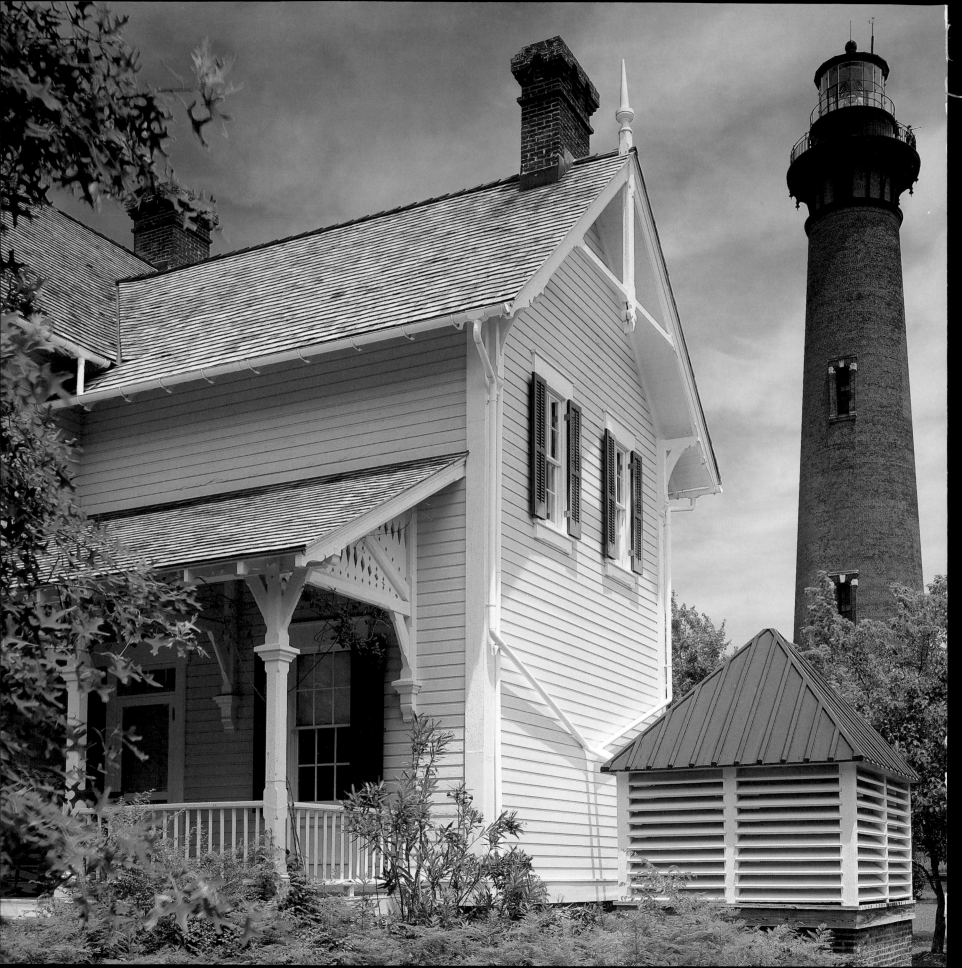

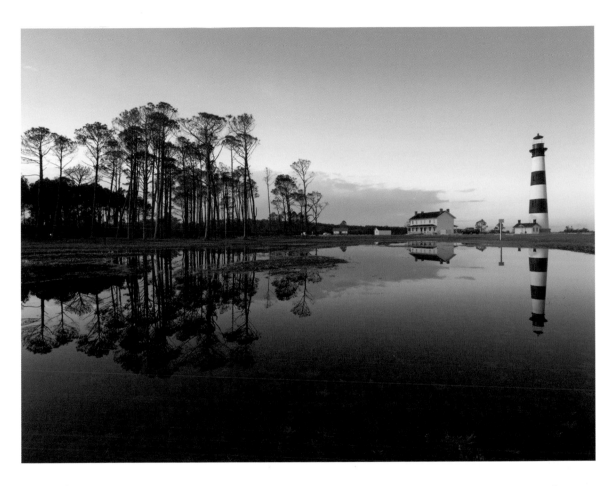

Bodie Island Lighthouse was built in 1872 to warn vessels of the treacherous shallows and sandbars. The island was named for the number of bodies claimed by these waters.

Built in 1870, the Cape Hatteras Lighthouse is the oldest brick lighthouse in the nation. At 207 feet, it is also the tallest. Erosion of the shoreline has forced the National Parks Service to move the landmark inland.

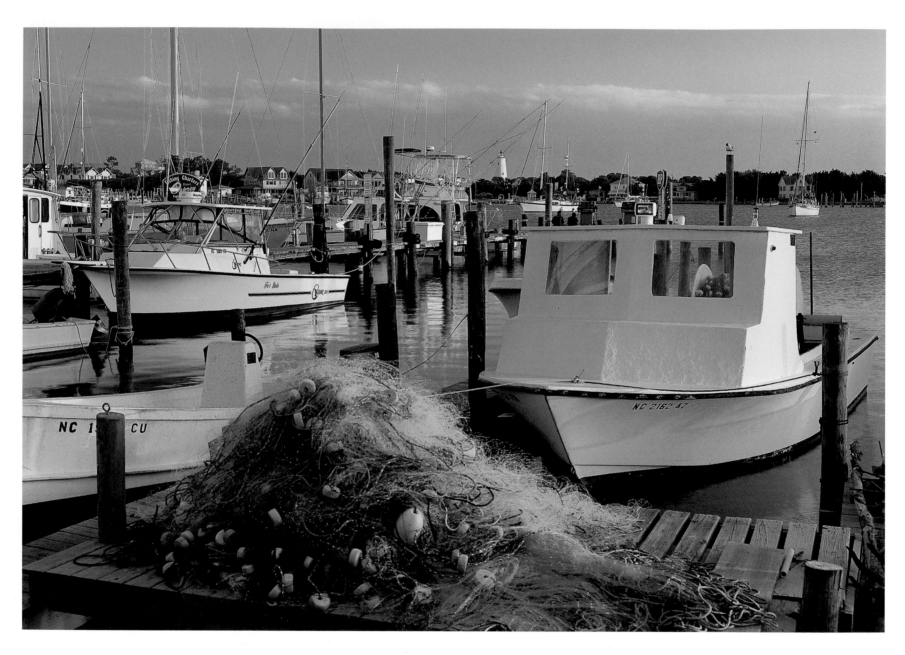

Nestled along the Outer Banks, the tiny island of Ocracoke offers
visitors a glimpse into the area's rich seafaring history.

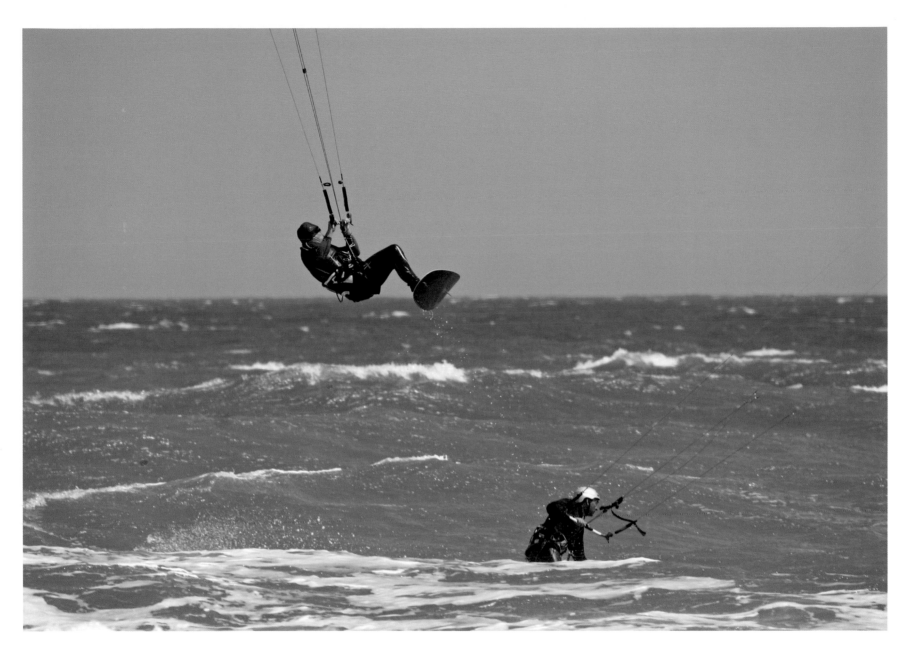

Sunseekers flock to Bodie Island each summer, enjoying water sports, charter fishing, birdwatching, golf, and more. The remains of shipwrecked vessels, including the *Laura Barnes,* which foundered here in 1921, are visible from the island's beaches.

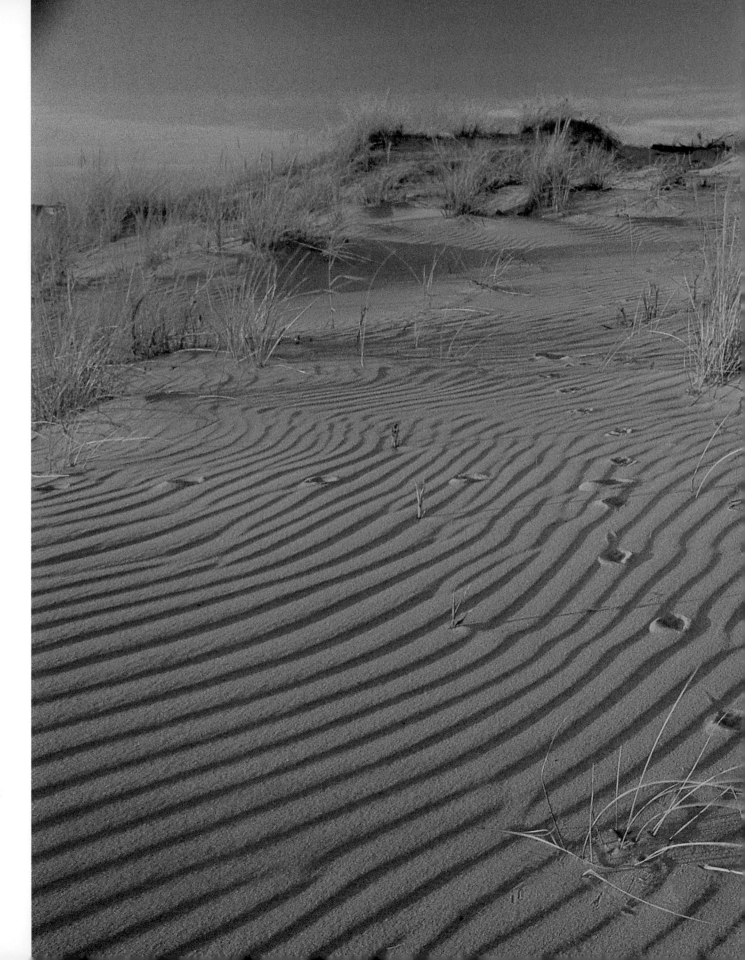

Encompassing the highest sand dune on the east coast, Jockey's Ridge State Park offers board-walks with views of the dune, picnic areas, and even dune buggies to speed sightseers over the unique terrain.

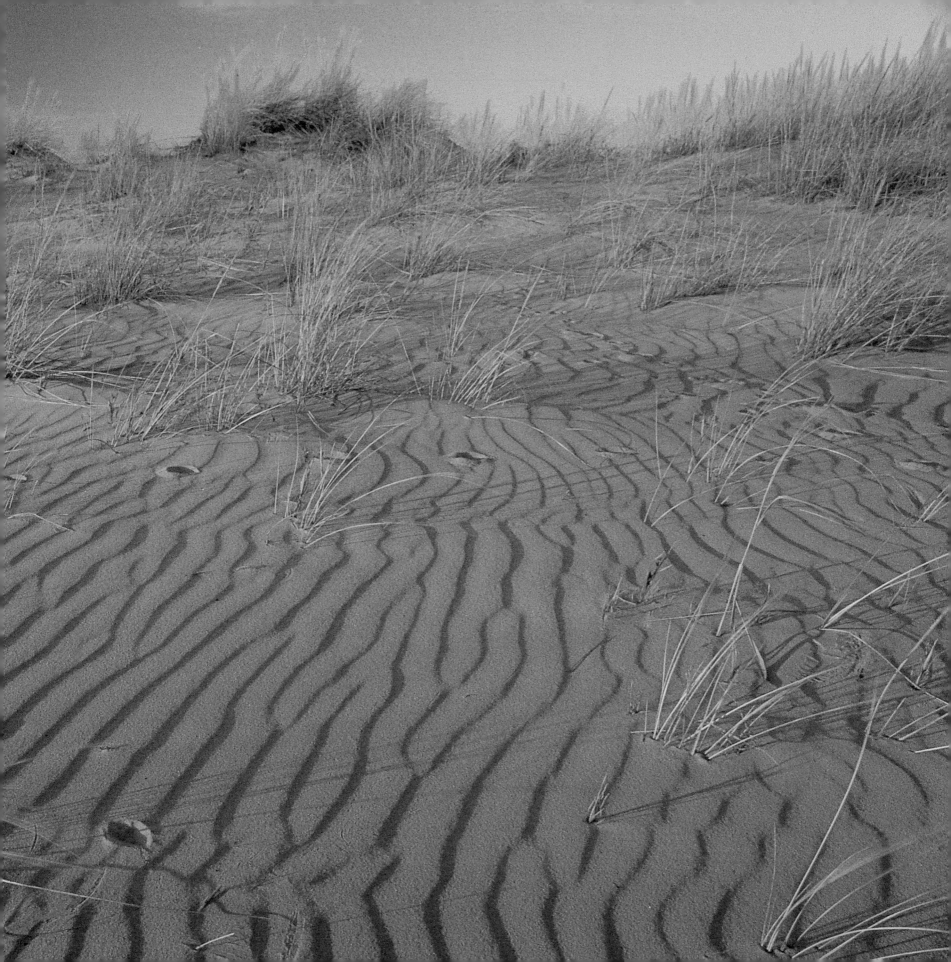

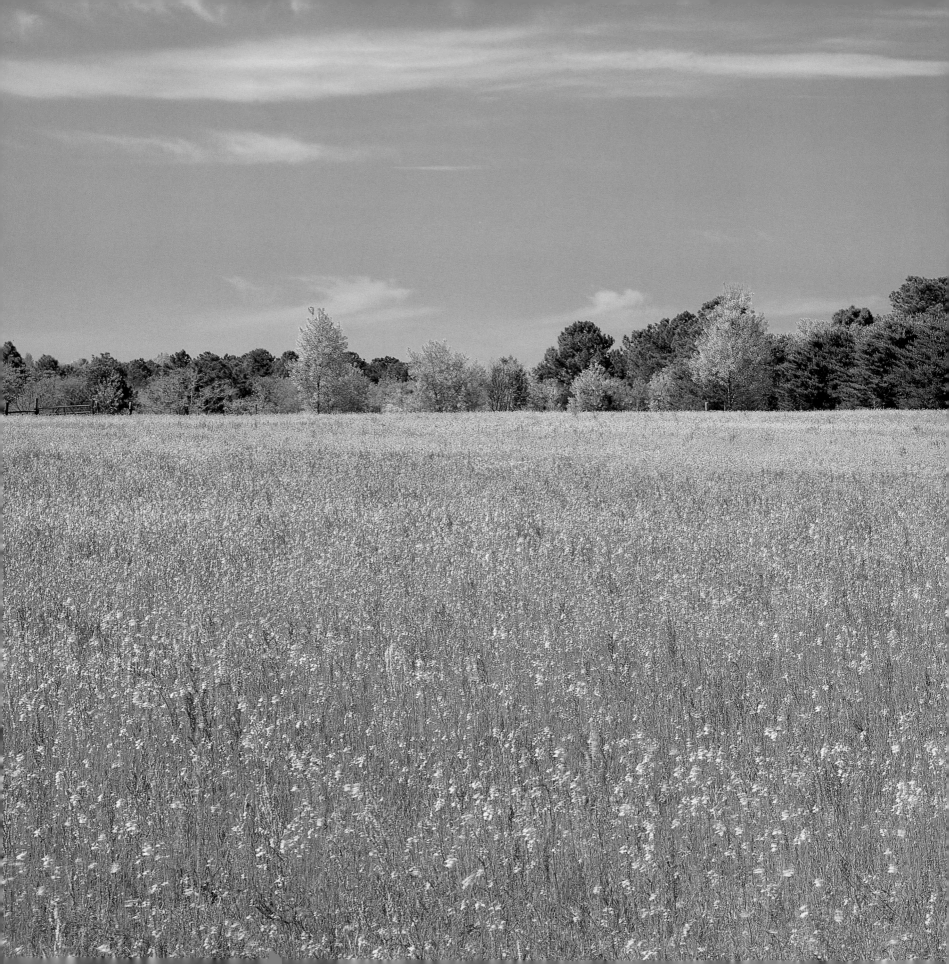

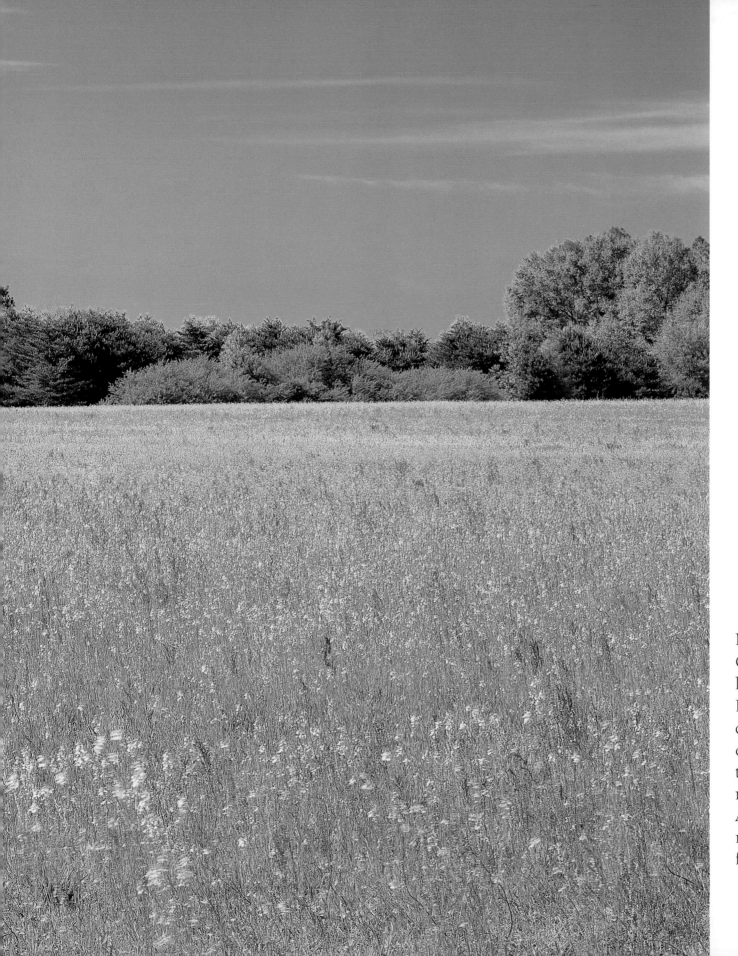

Much of North Carolina's agricultural land was once marsh. In the early 19th century, an influx of immigrants arrived to claim and drain much of the land. A census in 1860 recorded 85,198 farmers in the state.

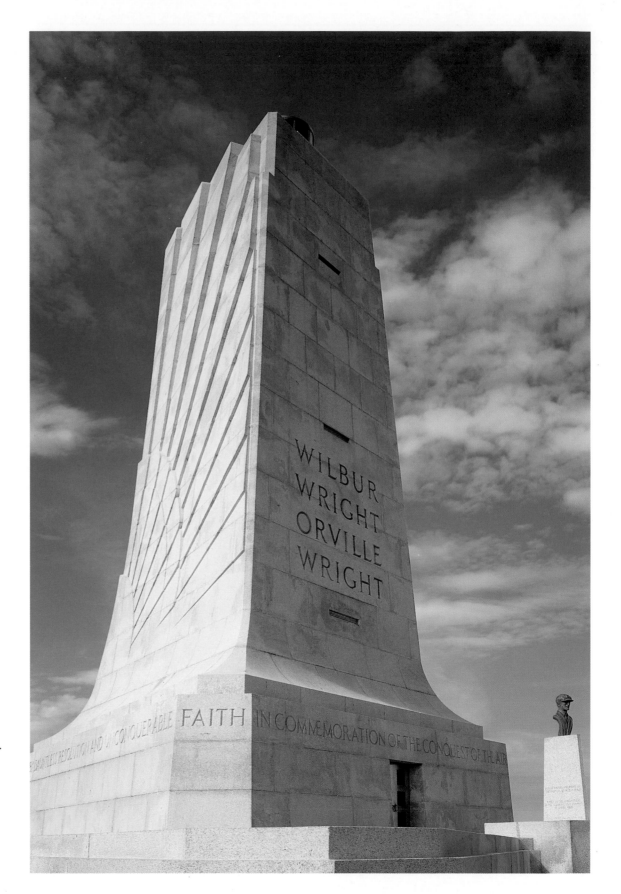

Wilbur and Orville Wright seemed like ordinary men until December 17, 1903, when they took to the air in Kitty Hawk, North Carolina. Within a few years, they could achieve heights of 360 feet and sustain flight for two hours. A 60-foot granite memorial at the Wright Brothers National Historic Site celebrates their achievements.

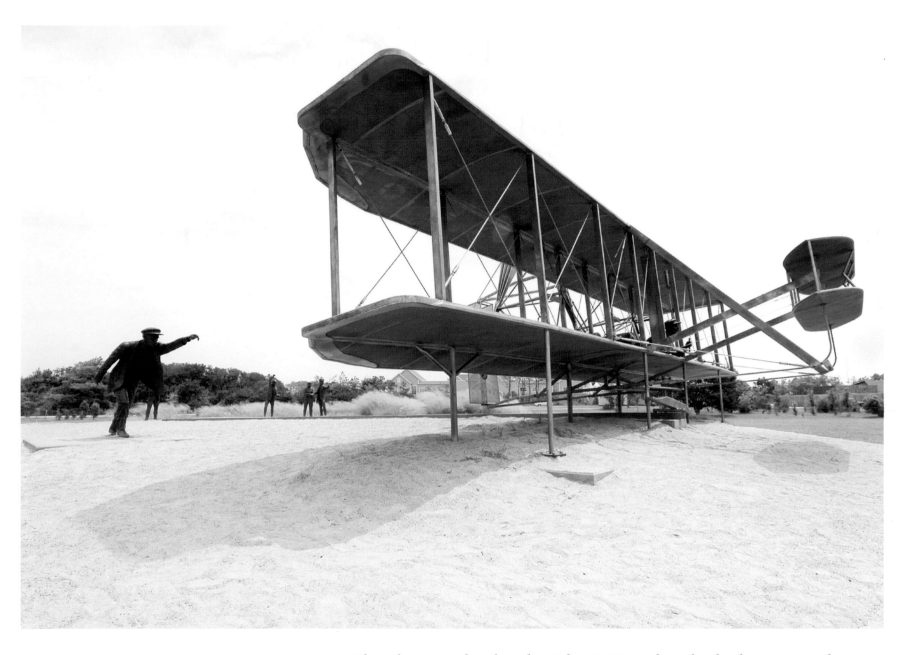

The photograph taken by John T. Daniels, who had never used a camera before, gives only one perspective of the Wrights' successful first flight—from behind the airplane. Stephen Smith's "First Flight" sculpture atop Kill Devil Hill, unveiled during the 2003 Centennial, gives a complete picture of that historical event.

More than 265 bird species can be spotted in Pea Island National Wildlife Refuge, including peregrine falcons, piping plovers, and bald eagles. The refuge is also an important northern nesting site for loggerhead sea turtles. Because the temperature at which eggs are incubated determines the sex of loggerhead turtles, this may be the birthplace for most male turtles.